T0326693

DEAR JEFFIE

Published for the members of
the Peabody Museum Association
in a limited edition

1978

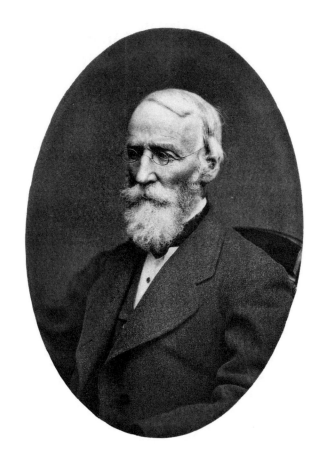

Jeffries Wyman

Dear Jeffie

Being the letters
from
Jeffries Wyman,
first director of the
Peabody Museum,
to his son,
Jeffries Wyman, Jr.

Edited by
George E. Gifford, Jr.

꿎VP

Peabody Museum Press

PEABODY MUSEUM OF ARCHAEOLOGY AND ETHNOLOGY
HARVARD UNIVERSITY, CAMBRIDGE, MASSACHUSETTS

1978

Dedicated to E.A.G., G.E.G. III, L.K.G.

ISBN 0-87365-796-9
Library of Congress Catalog Card Number 78-58830
Printed at the Harvard University Printing Office

PREFACE

Jeffries Wyman (1814-1874) was a pioneer anthropologist of nineteenth-century America and one of its great comparative anatomists. In 1847, he became the Hersey Professor of Anatomy at Harvard University and served in that capacity until 1866, "when failing strength demanded a respite from oral teaching, and required him to pass most of the season for it in a milder climate, he was named by the late George Peabody (1795-1869) one of the seven trustees of the museum, and Professor of American Archaeology and Ethnology, which department this philanthropist proceeded to found in Harvard University." George Peabody's bequest made it possible for Wyman to travel and study — spending the winter in Florida and the summer in Maine — an important asset for a man suffering pulmonary tuberculosis. As Asa Gray has written, "Winter after winter, as he exchanged our bleak climate for that of Florida, we could only hope that he might return. Spring after spring he came back to us invigorated, thanks to the bland air and the open life in boat and tent, which acted like a charm; thanks to the watchful care of his attached friend, Mr. Peabody [George Augustus Peabody, 1831-1929], his constant companion in Florida life."

It was at this point in life that Wyman was studying the ancient shell mounds in Florida and Maine. The result would be his classic work, *Fresh-Water Shell Mounds of the St. Johns River, Florida* (1875).

The fifty-nine letters in this slim volume were written by Wyman to his only son, Jeffie, born in 1864. The letters begin when Jeffie was two and continue until Wyman's death in 1874, when Jeffie was ten. Wyman, sometimes stern, sometimes funny, always had something to tell. The letters show a fatherly concern that his son be impressed with the rich variety of sights, sounds, forms, smells, and colors that enhance life. These letters are the work of a great scientist trying to instill in his son the concepts of acute observation and wonder. They are capped by charming, quizzical drawings that enrich and embellish the text.

Wyman's papers on biology and anthropology are profound and significant; his letters to Jeffie are like the little piano pieces for children by Bach and Beethoven — charming, simple, and elegant — but displaying the hand of a master. Like the piano pieces, they can be appreciated by children and adults alike. Children can appreciate the descriptions and adventures; adults can glimpse the humanity and pathos of this great humanistic scientist.

v

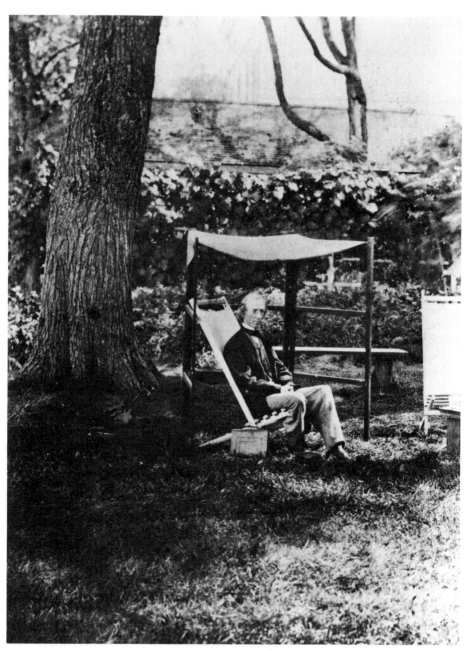

Photograph of Jeffries Wyman taken by Oliver Wendell Holmes on August 11, 1865.

LETTERS TO JEFFIE

EDITOR'S ESSAY

I became acquainted with Jeffries Wyman when I discovered a collection of his letters to David Humphreys Storer at the Boston Museum of Science. Some of the letters gave a graphic description of his life as a medical school instructor in Richmond, Virginia. These were published as "Twelve Letters from Jeffries Wyman, M.D., Hampden-Sydney Medical College, Richmond, Virginia, 1843-1848," *Journal of the History of Medicine and Allied Sciences*, vol. XX, October, 1965, pp. 309-333. Other letters from Paris, written during his postgraduate medical studies, were published, "An American in Paris, 1841-1842: Four Letters from Jeffries Wyman," *Journal of the History of Medicine and Allied Sciences*, vol. XXII, July, 1967, pp. 276-285, and "Jeffries Wyman — an Addendum," vol. XXIII, October, 1968, pp. 387-389.

In 1969, I met Anne Wyman, the great-granddaughter of Jeffries Wyman, and asked her if she had any Wyman material. She told me she had a "barrel of letters," in the cellar of her house which belonged to her father, Professor Jeffries Wyman III. This material previously had been used by A. Hunter Dupree for his articles, "Some Letters from Charles Darwin to Jeffries Wyman," *Isis*, vol. 42, 1951, pp. 104-110, and "Jeffries Wyman's Views of Evolution," *Isis*, vol. 44, 1953, pp. 243-246.

Anne Wyman and Professor Jeffries Wyman III deposited these letters on temporary loan at the Countway Library in January 1970, so that they could be preserved, indexed, and used by scholars.

I can well remember the evening that we looked at the contents in the barrel. There, neatly labeled and tied with ribbon, were stacks of letters to Jeffries Wyman from Alexander Agassiz, Spencer Fullerton Baird, Henry Pickering Bowditch, Elliot Coues, Charles Darwin, Ralph Waldo Emerson, Augustus Addison Gould, Asa Gray, Joseph Henry, Joseph Leidy, S. W. Mitchell, Richard Owen, B. Silliman, Jr., John Collins Warren, and letters from his brother, Morrill Wyman, and his father, Rufus Wyman.

The barrel also contained letters to his son Jeffie, not only describing his scientific activities, but revealing his concern and love for his only son, from whom he was separated because of his ill health. It seemed to me that these letters, with their charming sketches, would make a splendid little book. I discussed the idea with Burton Jones, then Director of Publications at the Peabody Museum, and he, too, was enthusiastic. Anne Wyman gave permission to publish the letters. Later, Richard Bartlett, who succeeded Jones, took a special interest in the book, not only as its designer, but as its champion. Stephen Williams, then Director of the Peabody Museum, lent his support.

This project was brought to the attention of Philip Phillips, Honorary Curator of Southeast American Archaeology in the Peabody Museum. He was particularly interested, not only because Wyman had been the first curator of the Peabody Museum, but, like Wyman, Phillip's interests included mound excavation and drawing. With his interest and support, the project was transformed from a possibility into a reality.

I was very fortunate to have my wife, Laura T. Gifford, and our friend, Elizabeth L. Power, to decipher, decode and transcribe Jeffries Wyman's neat but cryptic script. His archaic spelling of some words, such as "waggon" and "ketch" have been retained, along with his abundant use of that labor-saving device, the ampersand.

It never occurred to me that, in addition to the barrel, there might be more Wyman material. Imagine my delight when I called Anne Wyman looking for a picture of young Jeffie, and learned that she had located a box of diaries, kept by Jeffries Wyman, from 1857 through 1869. She also had located two little sketchbooks, one of which was labeled, "Sketches Made by Jeffries Wyman." Written on the first page in pencil was:

> Pasted in March 28, 1914
> Sketches made by my father
> 1868-187-; pasted into this
> book in Cambridge, March 28, 1914
> with Aunt Alice
>
> for Jeffy Wyman 3rd J.W.

Anne Wyman also loaned me a photograph of Jeffries Wyman taken by O. W. Holmes, August 11, 1865.

I am extremely fortunate to have as a friend E. Ashby Hammond, Professor of History, University of Florida, Gainesville, Florida. One of his areas of interest is Florida history; he volunteered to read the letters and to offer annotations.

Biographical material about Jeffries Wyman is most readily available in the account by A. Hunter Dupree, "Jeffries Wyman," vol. XIV, *Dictionary of Scientific Biography*, 1976, and in *Dictionary of American Biography*, by Hubert L. Clark.

The classic biographical accounts of Jeffries Wyman are:

Gray, A. and Others, *Jeffries Wyman*, Memorial Meeting of the Boston Society of Natural History, October 7, 1874.

Holmes, O. W., *Professor Jeffries Wyman*, A Memorial Outline, reprinted from *Atlantic Monthly*, November, 1874.

Lewis, Frederic T., "Jeffries Wyman, August 11, 1814-September 4, 1874," reprinted from *The Boston Medical and Surgical Journal*, with an additional footnote on page 12, vol. 191, no. 10, September 1924, pp. 429-435.

Mitchell, S. W., "Jeffries Wyman," *Lippincott's Magazine*, March, 1875.

Packard, A. S., *Memoir of Jeffries Wyman 1814-1874*, read before the National Academy, April 18, 1878. Judd & Detweiler, Printers, Washington, D.C. Note: This volume has the complete works of Jeffries Wyman.

Peabody, George Augustus, *South American Journals 1858-1859*, edited by John Charles Phillips, Peabody Museum, Salem, 1937, pp. X, XII-XIV.

Putnam, F. W., "Jeffries Wyman," *Proceedings of the American Association for the Advancement of Science*, XI, 1876, pp. 495-505.

Wilder, B. G., "Jeffries Wyman Anatomist 1814-1874," from *Leading American Men of Science*, Henry Holt & Co., 1910.

—— *Sketch of Dr. Jeffries Wyman*, reprinted from *Popular Science Monthly*, January, 1875.

Two works that treat the history of Wyman's appointment as curator of the Peabody Museum are:

Schuchert, Charles and LeVene, Clara Mae, *O. C. Marsh, Pioneer in Paleontology*, Yale University Press, New Haven, 1940, pp. 46, 75, 227.

Brew, J. O., *One Hundred Years of Anthropology*, Harvard University Press, Cambridge, Mass., 1968, pp. 12, 13, 16, 35.

More recent historical evaluation of Wyman's place in anthropology are to be found in:

Goggin, John M., *Space and Time Perspective in Northern St. Johns Archeology, Florida*, Yale University Publications in Anthropology, No. 47, New Haven, 1952, p. 32.

Sabloff, Jeremy A., Introductory essay to *Fresh-Water Shell Mounds of the St. Johns River, Florida,* by Jeffries Wyman, AMS Press, Inc., New York, 1973, pp. VII-VIII.

Biographical material about Wyman's friend and benefactor, George Augustus Peabody (1831-1929), (distant relative of George Peabody [1795-1869], benefactor of Peabody Museum), is found in:

Peabody, George Augustus, *South American Journals 1858-1859,* edited from the original manuscript by John Charles Phillips, Peabody Museum, Salem, 1937, pp. IX-XI.

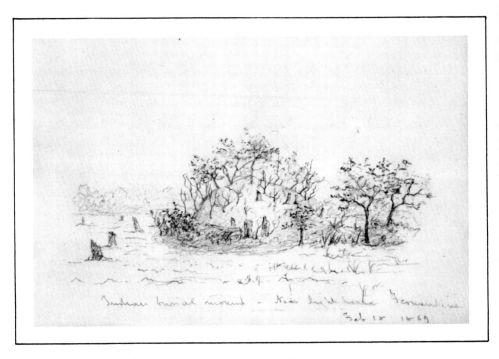

Indian Burial Mound – Near Light House – Fernandina – Feb. 18, 1869

THE LETTERS

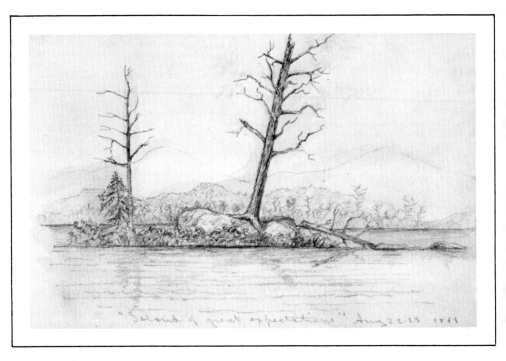

"Island of Great Expectations" — Aug. 22–23, 1863

Rawling's Pond
Alexander
Aug. 23, 1866

Dear Jeffie,

How would you like to come & stay with your Papa in the tent, & live in the woods where there are no houses, no horse cars & no "down town," & where you could not get any milk? We have no kitchen to cook anything in, and we eat our dinner, supper, and breakfast out-of-doors under the big trees, unless it rains, then we have to go into the tent & eat sitting on the ground, just as we did at the Oaks when we went to the picnic. While I am writing this, the man who helps me is cooking some beans & how do you think he does it without any range like that which Alice has in the kitchen? He digs a big hole in the ground, makes a fire in it until it is well heated, then puts in the pot of beans & covers them up & leaves them there all night, & in the morning they are all baked.

Do you remember the story in Mother Goose, of somebody who was frightened by an owl & ran away — If he was here, he could hear the owls make a great noise almost every night & so I suppose he would be scared all the time. There are a great many birds here & one of them, a very large one, lives on fish. I see him flying about every day over the water, & as soon as he sees a fish he drops down into the water & ketches the fish. But when he thinks he has got his fish to eat, another bird, a great eagle chases him, takes his fish away from him & eats it himself; isn't he a naughty bird to take from another what doesn't belong to him — I was very much pleased with the kiss you sent me & wish you could have given it to me with your own little lips. —

Affectionately, your Father

1

Palatka, E. Florida
Feb. 3d 1867
"Great Honour day"

My Dear Jeffie:

I have written to Susy & Molly & as this is your birthday I shall write this letter to you. I hope you are very well & by this time have been out of doors on your sled & have had a chance to coast. As you look out of the window & see the ground all covered with snow & ice, & when you go out find yourself all covered up with your coat & blanket, I am sitting at the table with the window open, & can look out into a garden, where peas & other things are growing. A little way off there are several groves of orange trees, where the oranges already ripe hang from the branches like apples, & as I walked along the road I picked & ate some of them. I wish you could be here to see them and play out of doors too, it is so warm & pleasant. It never snows here, & the little boys who live here never saw a sled or a sleigh.

I walked out before breakfast this morning, just to the fields, just as you and I used to do last summer on "great honour day" & picked some violets & other flowers, a few of which I send to you as a birthday present in this letter. This would be a very nice place to take our tent & go with Aunt Alice, Susy & Molly on a picnic. What a good time we should have. But then I am so far away, we shall not be able to do this.

I hope you had a good time at your birthday party & that you enjoyed it all very much. I wish very much that [I] could be at home just to see you for a few minutes, play with you & have you take one more ride on the "ephalnut." Do you think you could keep on his back if he were to kick up? Then I should like to see you at the table in your high chair. I wonder which side you sit on. I sometimes think perhaps Susy will take my place and you Susy's, but then I remember that you want someone to cut up your toast & meat & potatoe for you & so [I] think you sit just where you used to. How glad I should be to have a kiss from you before you go to bed, even if you did feel pretty sleepy & did not like to give me one. Well, I must give up all such things till I come home again.

There are a great many negroes in this place & last night they had a grand dancing party in a house close by the one I am staying in. I went to the door with another gentleman, & asked them if they would let us come in & see them dance. After a while they said yes, & so we went in. One negro

2

woman was dressed in thin white clothes, & danced with a man who had a big great coat on. There were about thirty of them in a large room lighted by three candles, & they seemed to have a very good time for they danced and sang until long after I went to bed. I think if you would have seen them you would have thought the sight a very funny one.

As it is now dinner time, & as I am going to take a walk afterwards I will stop here, & wish you a happy new year, my dear Jeffie. Give Papa's love to Aunt Alice, Sisters Susy & Molly & take ever so much for yourself. Give my love to Nana & each of the Aunts.

Affectionately, your
Father

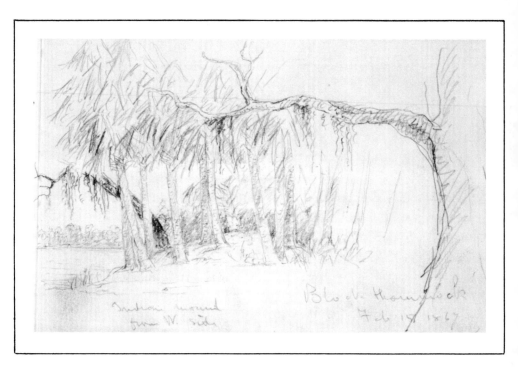

Indian Mound – From W. Side
Black Hammock – Feb. 15, 1867

Dear Jeffie,

As I have written to all the others more than once, this letter shall be to you. We came back to this place two days ago. When we went away the oranges were just ready to pick & now all the trees are in flower again, & every night the air is filled with the odor of them which makes it smell very agreeably. I send one blossom in this, which I am afraid will have lost its perfume before it reaches you.

We have very pleasant weather & find it quite warm. Our tents are pitched under a large oak tree, which gives us a very pleasant shade & are quite near to the water of the great lake. It is a very pleasant place & quite different from the one at another lake where we stayed several days, a picture of which I send in this letter, & where there was no shade at all.

Tomorrow I shall send five boxes of things down this river by the steamboat & then we shall start once more to work nearer home, where I hope to be before the end of this month.

I hope you are having a very nice time enjoying yourself very much — that you go out every day & have had a plenty of writing. Do you think you should like to go to school? Well, one of these days I suppose you will, just as Susy and Molly do now.

Give my best to sisters Susy and Molly, to Aunt Alice, Nana, & to all the other aunts when you see them.

I want to see you very much, my dear little boy, & trust I will in two weeks more if nothing happens to prevent my coming home.

Affectionately, your
Father

Cambridge, July 17 '67

Dear Jeffie,

We all miss you & Aunt Alice very much. There is no little boy to pound in the house or to dig in the yard & when we sit down at the table there are not enough of us to go all round by taking hold of hands.

The soldiers on horseback came to Cambridge today with the Governor to attend the college commencement. Benjie came down here to see them as they passed the end of Quincy St.

A little mouse came into my room night before last & made such a noise running about that I was obliged to light the gas & try to find him; but the little fellow was too quick for me & scampered off when I couldn't find him.

I hope you will have a very nice time & see all the pigs, cows, & horses in Billerica.

Susy & Molly send their love to you. Tell Aunt Alice that Molly wrote yesterday and that Susy will write tomorrow.

Affectionately, your
Father

East Eden Maine
Aug. 14th 1867

My Dear Jeffie,

 We have been at this place just one week & have had a very pleasant time, but today it rains quite hard & we have had thunder & lightning. Nearly every day we have been to see some of the curious things there are on this large island. We have been once on the top of a high mountain to which Molly, Susy & I walked. We went through the woods climbed over large rocks & when we got to the top of the mountain we could look over the land & islands in the sea, where were many ships & boats sailing, & others where they were catching fish. Yesterday they caught a very big fish, & he was so large that they were obliged to put him into a waggon & have a horse to drag him up from the shore.

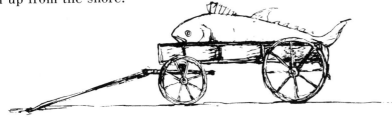

The waggon was as large as the ones people ride in & he filled it just as you see in the picture.

 Yesterday we went to see a great cave in the rocks. This is just beside the sea & the water comes into it every day. Sometimes people stay there a little too long, the water comes up & they can't get out without getting wet & if they stay in the water covers them all over & they are drowned. Near this is another hole in the rocks where the water rushes in & when it strikes the end of the hole makes a great noise & the water spouts out very far. They call this the thunder cave because the noise sounds like thunder.

 Would you not like to see all these things? Well, perhaps sometime when you are a large boy you will go with us just as Sally and Molly have done & if you do not see them we should see something else just as good. How should you like to go out in a boat, put a piece of string with a hook on the end of it into the water, & when a fish comes along & bites the hook pull him into the boat?

 Give Papa's love to Aunt Alice & Nana.

<div align="right">

Affectionately,
Your Father

</div>

Sally and Molly send their love.

My Dear Jeffie,

I have been wondering today what you were doing & whether it was as disagreeable a day in Cambridge as it is here. It has snowed and rained a little at a time since morning. I have seen quite a number of curious things, but the only one that I think you would like to have seen with me was the Mint where they make money. They were making today only one, two, three & five cent pieces. Did you ever think when you looked at a cent as you bought some candy with it how much trouble there was in making one? The building in which the money is made is a very large one, much larger than any in Cambridge. There is a large steam engine in it which turns a great number of machines, all of which must be used before one cent can be made. First of all there are some furnaces with very hot fires & into these they put some lumps of copper about as big as a tea cup and of this shape & as soon

as melted they pour the copper into a mold & it comes out a flat piece about

half as long as your arm and as thick and wide as my ruler. Then they put the piece into a machine with two rollers which squeeze it till it comes as thin as a cent, but at the same time much longer but of the same shape.

Then they put this into another machine which punches out some little round pieces which are to be the cents but the cents have not yet anything upon them. After they are punched out, the piece of copper looks like this,

each of the holes being the place where the cent came out. The machine stamps them so fast that a small basket was filled in a very short time. But the cent is not yet finished & only looks like a button. It is put into another

machine where the edge is turned up all round it, & then into another where the head is stamped & then into another where the other side is stamped with one cent marked on it. So you see it takes a great deal of machinery & a great many persons to make so little

8

thing as one cent. How would you like to have a machine which would make you as many cents as you wished? Have you had a chance to see any more plumbers? I hope not for it makes a great deal of trouble to have them about, although they amuse you very much. I went to a store today and saw a zoetrope with some very funny figures, one was a dog with a monkey on his back & the monkey jumps through a ring as the dog runs round. Another picture has a pig on it eating corn & as he ate he grew very large & all at once became a very small pig again — but as I have bought two or three new pictures for your zoetrope I will say nothing more about them as you will see them when I come home.

<div align="right">Affectionately, your Father</div>

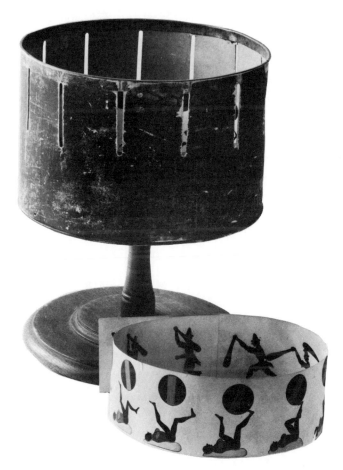

Zoetrope, with an animation strip, an early optical toy which produces apparent motion when the slotted drum is spun. Courtesy of the Children's Museum, photograph by Hillel Burger.

Elliot House
Washington, 26th April '68

Dear Jeffie,

I arrived here this (Sunday) morning at 4 o'clock having been three nights & two days on the Rail-road from Jacksonville. Luckily this time we had no "Smash up" or accident of any kind & I am thankful for that. Steady travelling by day & by night is hard work, but then the sleeping cars help to make it easier. The second night I failed to get a berth & so had to do the best I could in an ordinary car, but made out to get a good share of sleep, though not of the most refreshing kind. Last night I went to bed at 8 o'clock & slept till 4 this morning when we reached Washington, waking up but once during the whole time. Immediately after I got to my room I went to bed again & slept till nine & so I have made up the lost time. The great trouble in travelling in the south is the difficulty of getting good food. Everything is very badly cooked & of a very poor kind. The coffee is made of beans, the beef steak is fried in grease, & everything else equally disagreeable — At one place a man who kept a restaurant had a sign *Rocky Mountain House Eating and Drinking by R.A. Hammet.* He doesn't say how much he asks for people to see him eat and drink.

The post office will not be open till ½ past six, when I hope to find some letters from home bringing the good news that all are well. I shall probably stay here for some days or until I find out what the weather is in Boston, & if it is suitable for me to return. I find my cloak very comfortable here as the weather is so much cooler than in Florida where I have not put it on for several weeks. With love for yourself & all.

Affect'y, your Father

10

Cambridge, July 5th 1868

My Dear Jeffie,

I hope by this time you have found Jaffrey a very pleasant place & like to be there very much. Though we miss you every hour I am glad you were not here yesterday and are not today, it is so terribly hot. Yesterday we went to your Uncle Edward's in Newton to spend the 4th of July & they were very sorry you were not there too, & so was I for we had a very nice time although it was so hot — We went in a carryall at half past ten but were obliged to drive very slowly for the poor horse had a very hard time on account of the heat.

Your Uncle Edward had a large tent under which we had our lunch of cake & lemonade. We fired some guns along through the day, & at evening five at once, which made something of a noise. Little Sister Wolcott enjoyed it all very much. A paper balloon which was made last year but not finished in time to be sent up was sent up just at sunset yesterday, & as soon as it rose Mr. Wolcott and little Monica started in waggon to find it wherever it might come down. They brought it safely home & perhaps next year it will go up again. In the evening we had various kinds of fireworks & then we started for home, which, we reached about eleven o'clock pretty well tired out. We saw nothing of the balloon from Boston but I suppose it went up as there was no wind.

Molly and Susy are awake and send their love to you, & would be very glad to take a look at you. How does your new shovel work, & is the waggon large enough for you to help Mr. Spaulding get in his hay?

Affectionately, your Father

11

Bar Harbour, E. Eden
August 16, 1868

Dear Jeffie,

After we left home in such a hurry we took the cars in Boston at 3 o'clock, & stood in them till 8 in the evening, after you had gone to bed, when we had our supper. We then went on board the steamboat and stayed all

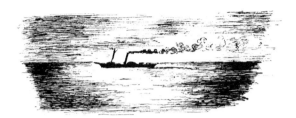

night & after travelling the whole forenoon reached this place in season for dinner. There are so many persons in the house that they have two large tables in different rooms. When I went to bed last night I sent Molly down for a lamp, but when she tried to bring it up the wind blew it out, & to light it again she would have been obliged to go down two flights of stairs, but I said I could do it without all that trouble & so I pulled out a match-box that a good little boy that I know of gave me on my birthday, & we had the lamp lighted very soon.

We have not taken any long walks yet & so I cannot tell you yet anything about the woods & the seashore — but hope to when I write again.

I hope you will write soon & send me a good long letter.

Affectionately,
your Father

Dear Jeffie,

I have not yet had an answer to my letter but hope to have one soon. I shall be very glad to hear from you & that you are having a good time at home. I wish you could be here some time to go with me to the place where they catch fish — How do you suppose they do it without any hooks or lines? They build a long fence in the water like the lines I have drawn below.

Then the fishes swim towards the fence, as they cannot get through they go until they come to the round place where they keep swimming round & round, but do not seem to know enough to go out. When a large number collects, a man goes in with a boat & net to dip them all out — Sometimes very queer fish get into their trap. One of them which we saw when we walked in with our rubber boots on, is called a wolf-fish because he is so ugly & has such awful bad looking teeth.

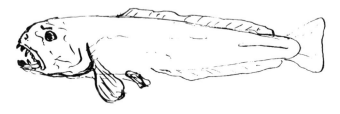

He is about as long as you are & weighs nearly as much as you so you see he is an ugly creature to have take hold of your heels if you were walking in the water.

There is another that they call a fool fish, because when he is thrown out upon the ground by the waves they do not know enough to get into the water again — it is larger than the wolf fish.

13

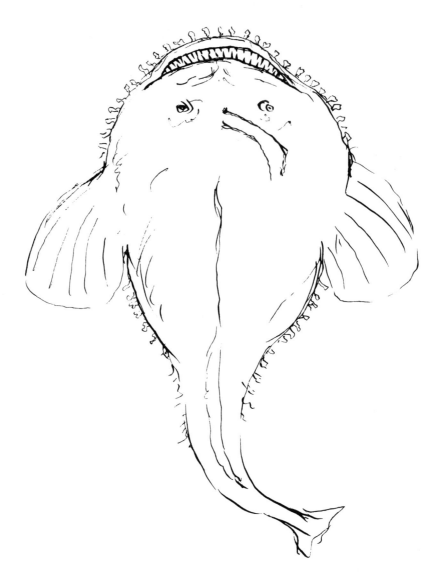

The mouth opens upwards & in the top of his head is a little slender bone with a sort of flag on it which looks like a worm. He hides himself in the weeds at the bottom of the water & moves the little flag when the other fishes thinking it is something to eat come to bite it: then he opens his big mouth & swallows the fish. There is a second bone which you will see behind the first but it has no flag. There are several other very curious fish but my paper is not large enough to allow me to give you an account of them. So good-bye, my darling boy.

Affectionately, your father

14

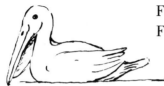

Fernandina, Florida
Feb. 21, 1869

Dear Jeffie,

While I am walking about here where the grass is green & the flowers are to be seen everywhere, I wonder if you have had any more snow and ice with coasting and sliding. Here it freezes sometimes but almost never snows. The birds here are very different from those you see in Cambridge & I have drawn one of them at the top of the page. It is a very large bird, as big as a large turkey, & is called a pelican. He lives on fish & ketches them in a very funny way. As he flies along over the water, as soon as he sees a fish, he dives into the water, opens his large mouth just under which he has a bag, which you will see in the figure, holds up his head, shakes the fish into his bag & after having caught a good many, swallows them one at a time until he has finished his dinner. When his bag is full it looks like this.

How should you like to see one of these curious creatures? There is another bird which follows him & as soon as the pelican has caught a fish, begins to worry him, trying to make him give up the fish he has caught — & so is [a] mean bird —.

I hope you say your lessons and learn something every day, so that when I come home I shall hear you say a good many things that I have not heard you say before.

Good night, my dear Jeffie,
Affectionately, your Father

15

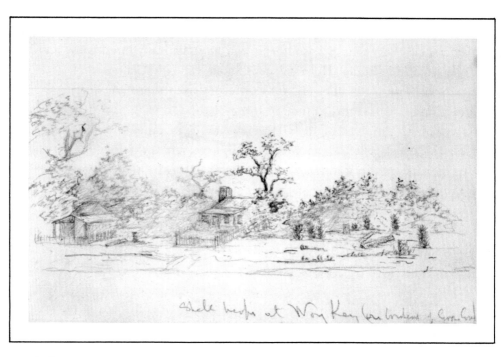

Shell Heaps at Way Key (On the border of Goose Creek)

Jacksonville, E. Florida
April 15, 1869

My Dear Jeffie,

If I have not written to you oftener, it is not because I have not thought of you. I think of you & all at home every day & was very glad to get your letter, but very sorry indeed that you have been a naughty boy. As you have been naughty, it was right that you should tell me of it, & I hope you will always tell me, even when no one asks you to do so. When you do anything you think is wrong or naughty, tell Aunt Alice or someone & then you will feel a great deal better about it. Then you must try as hard as you can not to do so any more.

As you say you are sorry for what you have done, & promise not to do it again, I hope when I come home you will be able to tell me you have been a good boy & that you have not been punished a single time — but if you do not behave well, you must recollect that you will be punished in some way.

I was pleased to read what you wrote with your own hand about going out with your velocipede. You have printed the letters very well & if you try [to] make some every day you will soon learn to write.

I send you in this letter a piece of silver money which I found on the banks of the Miami River where, I suppose, it was lost during the Indian war when the soldiers were there many years ago.

At Cedar Keys, I saw a great many soldiers all living in tents like mine. They had large fires to cook by, & kept them burning all night — for there is always somebody awake to guard the tents & stop every one from going to or leaving the camp. Every soldier takes his turn in sitting up a part of the night to guard, & they are obliged to walk backwards and forwards with a gun on their shoulders as long as their turn lasts. How should you like to be a soldier?

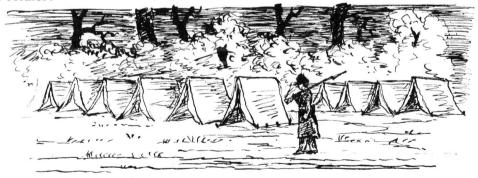

Supposed to be midnight, but the artist is not a master of light & shade except in the daytime. Thank you for your love and kiss, dear Jeffie — I send you mine.

Affectionately, your Father

Jacksonville, E. Florida
Sunday, April 18th 1869

My Dear Jeffie,

I received your letter asking why I do not write to you today. Well, Jeffie, I am sorry to say that I do think you have not had your share of letters, though I have written very few to anybody. I wrote to you a few days since & hope that you will have received it long before this reaches you. In two days more I shall be coming towards home & if Molly comes to New York, after we have had a few days there, shall hope to be in Quincy St. again, & actually be able to see a little boy I know of who lives in the corner opposite Prof. Agassiz's house — & find out whether he has grown any since I left home.

It is very warm here today & I am writing with my coat off & the window wide open. There are plenty of flowers growing in the garden, all the trees have leaves upon them, & you would suppose that we were in the middle of the summer. Last night I slept with the window open, it was so warm, & so was troubled with the mosquitoes. They are very troublesome everywhere in Florida & when we slept in the tent were obliged to hang up a net over ourselves to keep them off. They came round in thousands trying very hard to get inside of it but all they could do was to buz and sing, & so we went to sleep & did not care for them — the drawing will show how we slept one night on the top of an Indian mound without any tent, having only a net & blanket to cover us.

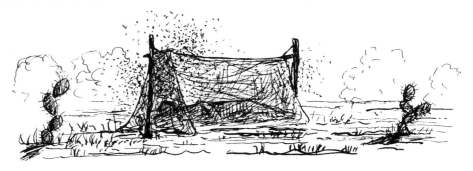

Affectionately, your
Father

Cambridge, July 16, '69

Dear Jeffie,

I received today your letter which came with Aunt Alice's. I am very sorry indeed you give so bad an account of yourself. When you went away, I hoped you would be a good boy & be kind to everybody, especially to your Aunt Alice & Aunt Mary who have been so good & kind to you. To talk to them as you did was very wrong. I am glad you told me of it, but hope you will not behave so badly again. If anybody asks me how you get on at Bethlehem, I shall be very sorry to think you have done things I should dislike to mention — because they are wrong. So I hope now you will behave so well that I can take pleasure in telling of everything you say you have done, & be obliged to keep back nothing. If you behave well you will enjoy your visit so much better & feel so much happier that I know you will be glad of it as long as you live (a long way of saying "be good and you will be happy").

It is very warm here today but a shower has just begun & I hope it will soon be cooler again. There was a thunder shower a few days ago & the lightning struck the chimney of a house at Fresh Pond & hopping down into the kitchen, among other things knocked a pan out the hands of a woman, while she was carrying it, but did not hurt her. The Lancers came through Cambridge yesterday & returned down Cambridge St. just after tea.

Sally & Molly send their love to you and to Aunt Alice and Aunt Mary, & also to Benjie —

Now, my dear child, be a good boy, so that you can write me a better account of yourself than you did in your last letter.

<div style="text-align:center">

Affectionately,
your Father

</div>

I send another illustrated paper today.

Cambridge, July 29th, 1869

My Dear Jeffie,

I hope you are having a very nice time in Bethlehem & enjoying the farm & everything belonging to it. I suppose you have had some very nice rides in the carts as well as in the waggons. Which do you like best, a ride in an ox cart or in the waggon? Would you like to ride far on the top of a load of hay?

We have had very warm weather here for several days & shall be very glad when it becomes cool again. We expect to go to a picnic on Saturday but if it is as warm as it is today I think it will be better to stay at home. Susy has been working hard all day packing her new trunk, so as to be ready to go to Rye tomorrow if she is well enough, for she has gone to bed with a pain in her stomach, but I hope it will be better before morning. Aunt Lizzie, Craigie St, is not very well & so I suppose she will not be able to go to the picnic. This is to be at a pond in Lincoln where there are some boats, & we can have a row in them if we wish — Would you like to be there, too? The drain in the College Yard is not yet half finished, but they are working hard in the deep trench in which it is to be built. The spire of the baptist church is almost finished, & we can see the men from Susy & Molly's window, working up in the very highest part of it. In a day or two the staging will be taken down, when no one will be able to go up there. The new church opposite the end of Ash Street is not yet finished & a part of the front has cracked so badly that it will be necessary to take it down & build it up anew. This is very unlucky & I suppose the owners will feel very much disappointed. The steam engine hoisting the stair has, I believe, been taken away.

I am very glad to hear that you have been a better boy & I have no doubt you will do very well now, & I shall be glad to know the next time I hear of you that I have not been mistaken.

Give my love to Aunt Alice & Nana, also to Benjie & keep a good deal for yourself. Molly & Susy would send their love too, but they have gone to bed.

Good night, my dear boy,

Affectionately, your Father

20

Glen House — White Mountains
August 29, 1869

Dear Jeffie,

I had a letter from your Aunt Alice two or three days ago & she told me you had been a good boy & so the first thing I wish to tell you is how glad I am. that she could say something of you that is so nice and pleasant. I hope the next letter will give just as good news. Molly & I are having a very nice time among the high mountains, which we can see all around us, but which are, sometimes, as they were this morning, all covered with clouds. After a while the clouds open & let the sun shine in, making beautiful patches of bright light on the green trees which cover the mountains almost everywhere, except on the tops. We have not been up onto the highest mountains yet, but hope, if the weather is fair, to do so tomorrow. Sometimes travellers start to go up the mountain when there are no clouds to be seen, but, before they get up to the top the clouds come over them, so that you can see nothing as far off as across the room. Several years ago, three persons tried to walk up the mountain without anyone to show them the way, & when they had almost reached the top, a cloud came over them with a strong wind, all of which made it impossible to find their way any farther & when they all sat down to pass the night, one of them, a young lady, became so chilled that she died before morning. When the sun came again, they found that they were within a few steps of the house on the top & for which they were searching.

This morning Molly & I walked to a place a mile below the hotel, where the river has worn large holes in the rocks, some of them only large enough to hold a few capfulls of water & others so large that three or four barrels of water could not fill them. They are all worn out very nice and smooth, and are mostly quite round. How do you suppose the water can wear a hole in a hard rock? All it has to do it with is a stone which it keeps turning round and round. As the stone turns, it rubs off a little of the rock, & although in a whole year there would not be enough of wearing to be easily seen, at the end of hundreds of thousands of years a deep hole is made — Sometimes the stone is washed out & then the hole waits years, perhaps, before another takes its place. But sooner or later one does & in the course of time many holes are made & at last the rock is cut away & a smooth passage is left for the river. Last night it rained quite hard, & the woods are quite muddy, but by tomorrow we hope it will be dry enough for us to enjoy the ride up to the top of the mountain, or at least to see some of the waterfalls, of which there are two very nice ones within walking distance — Give my love to Aunt Alice & to all in Ash St.

Affectionately, your Father

21

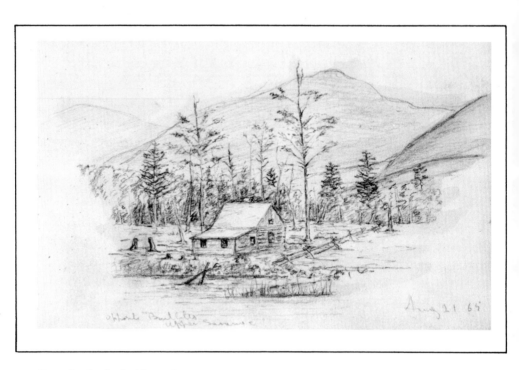

Opposite Bartlett's, Upper Saranac
Aug. 21, 1865

Old Town, 4th April 1870

My Dear Jeffie,

The last mail brought me only one letter & that was from Molly. Today I was greatly delighted by receiving *seven*, four from Quincy Street, including one from you. There was also one each from Aunt Lissie, Craigie St, Dr. Storer & Mr. Winthrop.

I am sorry you were so unfortunate as to lose both your money & your slippers, but I hope this bad luck will teach you to be more careful in the future. I suppose you could not help losing your money, but it is best to remember always before laying anything down to find out first whether there are others about that you do not know. There are plenty of naughty boys ready to take anything belonging to another that they can lay their hands on. The best way is not to lay things down at all unless you are sure they will be safe.

The weather is growing quite warm here, & the thermometer stood today at 89 in the shade, but this is unusually hot. We shall leave this place on Monday, (April 7th) & then work our way down the river in our boats. We are now over a hundred miles from Hibernia, but could travel the whole distance in three days if we wished — & that would be taking it quite leisurely.

Your Aunt Alice says you have brought home good reports from school which pleases me very much. I shall certainly always be pleased to hear good accounts of your progress in school. Everything that you can learn now ought to be a help to you as long as you live, & I hope you will get as much knowledge as you can.

The eggs of the wild ducks are hatching now & we have seen the old duck with her brood of young ones swimming after her. The old ones are quite cunning when there is anyone after them. They leave their young & go off making believe that they have a broken wing & pretend not to be able to fly. When they have driven off the pursuer far enough so that the young ones have had time to hide, they fly away, as much as to say, "Catch me if you can." Last night I was waked up by the falling of a large tree just across the river. First, there was a great cracking as the trunk gave way & then a heavy thump & a general smashing of the limbs, all of which made a tremendous noise.

With love for yourself & all,
Aff'y, yr Father

23

My Dear Jeffie,

I was very glad to receive your little letter which came with Aunt Alice's & also your figures, which though not quite as well made as your letters, showed you were trying. We are now as far from home as we shall go, & when we leave this place we shall begin our journey back — If you were to be taken from Cambridge as soon as you had finished your supper & brought in an instant to Berlin you would find us in the middle of the night & that we had all been long in bed. The sun rises here six hours sooner than it does in Cambridge & when it is time for you to eat your breakfast they eat their dinner here.

Of all the things we have seen here I believe you would enjoy what they call the *Aquarium* the most. It is not a menagerie. There are a great many nice rooms fitted up to roam about in. In the first are some glass cases containing lots of snakes, turtles, frogs, lizards & all alive and crawling & hopping about. Some of the snakes climb up the trees in their cages & go to sleep there. Then comes a very large place fitted up for the birds & each different kind of bird has a small room for itself — but still as large as my sleeping room in Quincy Street. Of the many different kinds of birds, one is very curious on account of the nests they make & are called *weavers*. This drawing shows the form of the nest & the hole into which the bird goes. As he hangs down he is obliged to ketch hold of the edges with his claws & crawl up into his resting place. As there were a great many of these birds, they kept up a great chattering all the time & there were more than twenty nests all in the process of building at once. *(1 line missing)* was a Chimpanzee, an animal which of all others is most like a man. As he comes from a warm country, he is obliged to wear clothes in this cold climate. Instead of walking on his feet alone he is obliged to use his arms & puts his knuckles on the ground. When he eats a raisin he takes it in his thumb & finger, bites off the stem & spits it out, & when he lies down puts his two hands under his head just as a child would do, resting on one side — he has a mattress for a bed & covers himself with a blanket.

There are several rooms made of rocks so as to be just like caves, & around the walls are some glass tanks filled with water & containing a great many kinds of fishes. In one, several large catfish were swimming about & in another some eels, & in another a little fish called a sea horse, because his head is shaped so much like a horse. Then there are crabs and lobsters all alive, & crawling about just as they do in the sea, & ever so many other creatures, which many letters would hardly give me space enough to describe. But the collection is a very nice one & I know you would enjoy seeing it very much.

I am glad to hear from Aunt Alice's letter that you have been a much better boy & I have no doubt you will do the best you can to behave well, which will please us all very much & yourself, too. In my letter to her I sent you two drawings of some monks & as she said she wished I had sent one of them to her I enclose one which you can give her.

Molly and Susy are very well and send their love to you — They have been through the King's palace today & a very large museum.

Give my love to Aunt Mary & Alice & Eunice & to Aunt Lissie if she is home.

<div align="right">
With love for yourself,

Affectionately, your Father
</div>

Camp on Peabody River
Gorham
September 13, 1870

My Dear Jeffie,

I was very glad to receive your nice letter to-day. I do not know as I can explain well the best method of finishing your bedstead, but I am very glad you tried to make one. I suppose the parts you have made correspond to the two ends in this paper and all that is left for you to do is to nail on the side pieces *a* and *b*., which I think you can easily continue to do. If not, you must wait until I come home —

I had a funny accident yesterday which would have amused you had you been here. While cooking the dinner, I thought I noticed the odour of burning cotton & supposed the tent was on fire & immediately ran to see if such was really the case. Finding no fire & still perceiving the same smell, I began to look more sharply and found that a spark had got into my coat pocket & that this was burned almost entirely out. All of which your uncle & little Morrill enjoyed very much.

We have a nice little waterfall close by the tent & a swift stream running over the rocks near which you would very much like to play. I hope you will be all ready to go to school when the time comes. You are now getting to be a large boy & most boys your age know how to read.

Affectionately, yr
Father

Camp on Peabody River
September 21, 1870

My Dear Jeffie,

As all the other letters have been directed to someone else this shall be reserved for you & it will probably be the last one I shall write from this place.

We are still having very fine weather though the middle of the day is as much too warm for comfort as the nights are too cold. The mornings & evenings are, however, so pleasant that they more than make up for any discomfort we are put to by heat or cold.

All four of us are getting along very well & each enjoys himself. Who do you suppose the fourth person is? You will no doubt wonder, as we started with only three, your Uncle & cousin Morrill & myself. Well after we had been here a few days, a funny little stranger made his appearance, looking through the bushes seeming to be afraid to come into full view. After a while, he took courage & coming out, sat on a log very quietly looking at us, but went off at once if we attempted to go near him, or even moved — his dress is rather odd of a brownish colour with a white stripe on each side of his back & each stripe has a black border. He wears whiskers, but they do not cover the sides of his face, & consist of a few long stiff hairs scattered about each side of his face and mouth. His eyes are bright and black, & his ears are rather pointed. He is very quick in his movements & it would be of no use to chase him. He runs on his hands & feet, but when he stops he generally stands up & looks about very sharply. If disturbed, he runs off & just as he goes out of sight makes a very funny whistling sound.

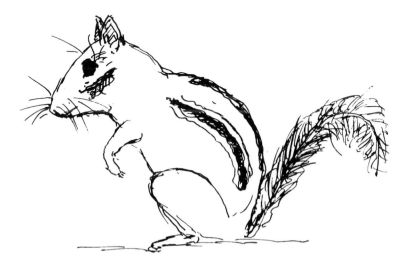

By treating him kindly & giving him something to eat he has finally got better acquainted with us, & now comes to the front of the tent for his breakfast, dinner, and supper. He makes very short stays & generally goes away as soon as he has got his meal. I forgot to mention that his coat has no pockets in it, but strange to say, he has two little bags on each side of his mouth and in there he puts all the extra food which he desires to carry away. He has never told us his own name nor asked ours, but for want of something better we call him chipmunk.

We shall probably leave for home on Saturday, but I suppose Chipmunk will not be persuaded to go with us, but we shall bid him good-by & leave him all the crackers & cheese we can spare. Give my love to Aunt Alice, Molly & Susy. I send you my love.

<div align="right">Aff'y, your
Father</div>

I suppose Chip-munk would send you his love, too, but he has gone out.

Horse Landing
Feb. 4, 1871

Dear Jeffie,

The first letter written in my tent shall be to you & would have been written yesterday, on your birthday, if we had not had some visitors who prevented my writing. However, I did not forget the day & I picked these flowers within a few steps of the tent & could have sent you lots more had it been worth the while.

We left Hibernia on Wednesday, Feb. 1st, the anniversary of our landing at Brest last year. Our party consists of Mr. Peabody, myself, Pompey and Smoke. Pompey is a colored man who cooks for us and Smoke is the very nice black dog who helps hunt the birds for our dinner. We went as far as Palatka in the steamboat & then launching & loading our small boats, we started 20 minutes after 3, Mr. Peabody & Smoke in the canoe, Pompey and I in the large skiff. When it came night we did not see any good place to go on shore to camp, & began to feel some doubt whether we should find any, when we saw some men loading a scow with wood. On going there we found nothing but a wood pile & a small clear space behind it & then woods and swamp. But we decided to spend the night, as we might go further & have worse. Pompey built a fire and we soon had tea. The moon was bright & the weather warm, so that notwithstanding the wildness of the place, it looked pleasant enough. The scow and the negroes who belonged to it soon left, still we did not have the place to ourselves. Soon there came two tall men with large hats & beards, rough clothes & guns. They were, however, very civil, built their own fire, and cooked their supper, after which we had a long talk. Pompey has a fiddle which he played for a while, when one of the strangers played several tunes & Pompey danced, making his heels fly to the sound of fiddle — It was very warm & the mosquitoes were flying about in crowds, so we put up our mosquito-bars, but not the tents, thus passing our first night in the woods. There are a great many owls here & we heard them hoot all night long. If you could have seen us I think you would have thought we had chosen a curious place to pass the night in. Well, we had a comfortable night, got an early breakfast, & started for this place where we arrived Thursday noon. Our tents are pitched on the top of a little hill, but completely sheltered by the trees. We can look out upon the river which runs directly past us. Today is a nice & cool one, the first we have had for some time, it having been too hot for comfort ever since our arrival in Florida. We remain here one or two days more & then start for another place higher up the river.

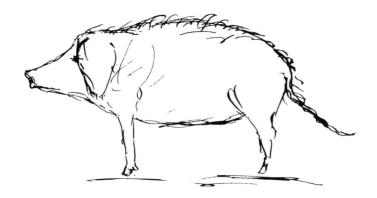

Yesterday we had some unwelcome visitors in the shape of wild hogs, but we soon sent them away, grunting with sticks following them pretty smartly. Some years ago, one of them got into Mr. Peabody's tent & turned all his things upside-down. So we do not allow them to come near us if we can help it.

I hope your birthday was pleasant & that you enjoyed it very much. I must tell you again how glad I was that you succeeded in getting all fours after I left. You have done so well lately that I have no doubt you will have many of them.

Give my best love to all & take a share for yourself,

Affectionately,
your Father

Old Town, St. Johns River
E. Florida
Feb. 19, 1871

Dear Jeffie,

When I heard that you were sick with a sore throat, I was very anxious to hear again, so that I might know how you were getting on. I should have felt more uneasy still if I had known that you had the scarlet fever. I was quite relieved when I got the letter Saturday night to hear that you were getting on so well, & that you & Susy were having good times. I hope the next letter will tell me that you are all well again. I am sorry that your sickness included your birthday, but, for all that, you seem to have got along very well & to have had some nice presents. As the weather has been so cold you would have lost some of your school days if you had not been sick.

We are having very nice warm weather here & stay in the open air all day long. We have had one thunder shower & one rainy day. The first came in the night, & every flash of lightning lighted up the tent so that I could see everything there was in it, & then it became so dark that I could see nothing. The rainy day was rather tiresome. Though my tent was perfectly dry, it is rather a small place to stay in the day time. However, [I] did some sewing, wrote some letters & finished various small jobs which I had on hand. Then we had to eat our dinners under the tent instead of the open air. Our table consists [of] four sticks driven into the ground with some end pieces & some boards resting on them. It is put under some orange trees with lots of oranges on them, but they are all sour ones — so we do not eat them though we make something very nice to drink with the juice. The orange trees are just budding & in a few days we shall have plenty of their sweet-scented flowers. Smoke, the dog, seems to have a very good time, & once in a while barks in the night when some of the small wild animals come round the camp to pick up some of the crumbs & bones that fall from the table. He helps Mr. Peabody hunt the birds we eat.

Hoping that when you get this you will be well & to school again —
Affectionately,
your Father

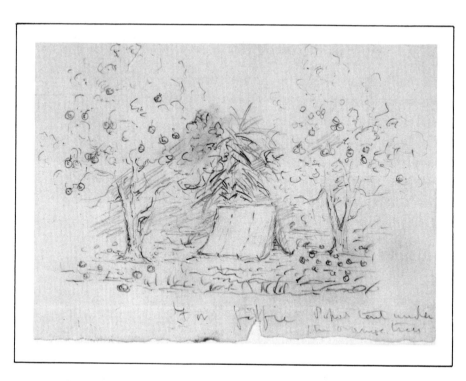

For Jeffy – Papa's Tent Under the Orange Trees

Old Town, St. Johns River
March 5th 1871

Dear Jeffie,

Among my last letters I was glad to find one from you & still more glad that you were able to write it yourself & direct the envelope. All this shows that you have got pretty well over the scarlet fever & then the letters from Susie & Aunt Alice tell me that you have been out to ride & to shovel snow.

We have been at this camping place almost three weeks & in two days more shall move again, going further up the river to a place called Blue Spring where a small river comes directly up out of the ground. We have had a very nice time here & everything is so pleasant that I shall be sorry to leave the place.

A few mornings ago we heard a great noise, like the bellowing of a bull, in the river & looking on the other side saw a large alligator with his head & tail up in the air.

They say that they begin to bellow just before a storm but I don't believe this is true for no storm has followed the bellowing when we heard it. They grow fifteen or twenty feet long so that one of the large ones would stretch across the whole length of the study. They kill dogs & hogs & sometimes men who venture into the water. When they come out on the land they seem to be very cowardly & when anyone comes near them they splash into the river making a great noise & commotion. Sometimes they rush directly under the boat.

Two bears were killed by some hunters a few days since, not far from our camp. There were here once a great many wolves but they are all gone now.

In about 5 or 6 days more we shall begin to come down the river again & shall be moving towards home. The weather is getting too warm to stay here much longer & I hope you will soon begin to have warm weather at home. The flowers of the orange trees draw a great many butterflies & hummingbirds around them. The new oranges are just beginning to grow. I send you my love, give it also to Aunt Alice and Susy & Molly.

Affectionately,
your Father

Blue Spring
March 17th 1871

Dear Jeffie,

I was very glad to receive today your letter beginning March 5 and ending March 10th. I have not yet seen Dr. Bigelow, but suppose he is somewhere on the river. I hope you got a good watch for your money & that it will go a year without cleaning. There are several kinds of owls here, one of which makes a noise like the one you mention. But another & more common one says *whoo, whoo, whoot-whoo.* Sometimes they seem to get into a quarrel, when they scold & say *whar! whar! whar!* as fast [as] they can, two or three joining in at once. I send you another letter with this, a skin which a snake had crawled out of. Two or three times a year a snake changes his skin. It gets loose all over his body, then it separates from the edges of his lips & as he crawls through the grass, the edges get caught by some point or rough surface, & the skin begins to strip off, as he crawls along, turning inside out. If you look at the head part you will see the portion that came off from over his eyes. When the snakes have just got rid of their old coat they look very nice and shiny. You must take the skin out & handle it very carefully for it is very easily torn. The one I send is a very perfect one & so you had better take care of it if you wish to keep it — I send also the wings of a butterfly which I had in my tent, but the ants came in after some sugar & water & at the same time ate up the body of the butterfly, leaving it as you see.

Today while we were eating dinner a whole train of floating islands, ten in all, came down the river. They are made up of plants growing in the water & consist of flags, yellow lillies, wild lettuce & a few others, the roots of which are all tangled together. They made a very curious and pretty sight. The day has been very hot, & now we are having a thunder shower which will, I hope, cool the air. We have had green peas for three days.

Give my love to all.

Aff'y, your Father

Hibernia, April 20, 1871

My Dear Jeffie,

I was very glad to get your last letter which was written very well, &
to learn that you had made for yourself a knapsack. You ask me to buy
Smoke, but I do not think Mr. Peabody will be willing to part with him.
Smoke has but very little to do, now that we have done camping. If he is
untied when the steamboat comes in, he goes down to the wharf by himself,
sits down, & takes a view of what is going on & comes back to the house
again when the boat leaves. On one of the boats they had an old rooster that
always went ashore whenever they stopped, picked up something to eat, & as
soon as they blew the whistle for everybody to come on board, the rooster
jumped onto the boat of his own accord.

I have been over to Gainsville, & saw what they call a *sink*, where a
large piece of land caved in & went down into the earth, carrying down a
great many trees with it. Such things happen here from time to time. One day
a man was riding on a mule when the land sank & down went man & mule, &
the man was obliged to shout for somebody to come & help him out.

It is very warm here now & yesterday we had strawberries & today
blackberries for breakfast, & blackberry pudding for dinner. We have had
new potatoes, beets, peas, and many other vegetables. I hope you have had
better weather in Boston than when the last letters were written. The mail
came today, but brought nothing for me.

I expect to start back the middle of next week for Washington, & shall
be very glad to get away from here where it is so warm. In my last letter,
which was to Molly, I expected to have my letters mailed to Washington.

With the best love for yourself & all.

Aff'y, your Father

My Dear Jeffie,

We had a letter from Aunt Alice yesterday who says you are much better, & I am very glad to know it. I hope you will be soon quite well again & enjoy every day of your visit in the country. It is very pleasant here, though today has been rather too warm for comfort. We had a thunder shower this morning just before daylight, & when I heard the first thunder I awoke, thinking the roof of Memorial Hall had tumbled down, but soon found that it was all safe and sound.

Your morning glories have had two flowers, one blue and one white, & look very nicely. Another marigold has also flowered & is almost all yellow. The beans have done flowering & some of the pods have very good-sized beans in them. The potatoes look very much the same as they did when you went away & I suppose will soon begin to have something underground, though I fear they will be "small potatoes & few in a hill."

I have bought a grindstone which came this afternoon & is now in the cellar. It turns with the foot like a sewing machine & has a trough to hold water.

So, I shall be able to grind my tools & turn the stone myself. However, it has a crank besides, which can be put on if necessary or if the other arrangement gets broken. Susy has gone to Nahant to spend the day & will come back in the steamboat at the same hour we did. I think it was rather too warm a day for such an excursion. A company of soldiers, the Cadets, is encamped there & have had rain almost every night since they went.

The building in the college yard next (to) the library is having the roof put on & will soon be covered in. The other building rises more slowly. I suppose the roof of the Memorial Hall will be boarded in a few days.

Molly & Susy expect to go to Connecticut next week, when I shall be quite alone again.

I hope the two illustrated papers I sent reached you. I send with this a copy of *Every Saturday* — which also has pictures.

Give my love to Aunt Alice, Aunt Mary & to Benjie, also to Aunt Eunice when you see her & with best love for yourself.

Aff'y, yr. Father

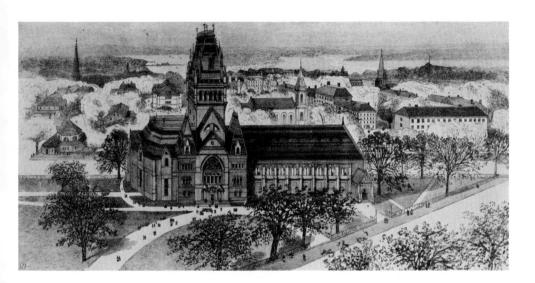

Memorial Hall, 1886, from *Frank Leslie's Illustrated Newspaper*, courtesy of the Harvard University Archives.

Cambridge, Aug. 6 '71

Dear Jeffie,

We have had very hot weather here for two or three days & I think you are very lucky to be at the mountains where I suppose it is, at any rate, much cooler. We have had several showers but no thunder or lightning. Your morning glories still have flowers & I have put in a larger stick for them to twine around.

The beans near the fence are growing well now & just beginning to blossom, & as they are taller than the others I have put a long stick for them to climb upon. The bush beans have got through growing, & the leaves & pods are beginning to dry up. The potato vines in the same bed with the bush beans have only very small potatoes about as big as cherries on their roots, but I have no doubt that those near the fence will have larger ones, but I have not examined them.

The corn has hardly grown at all & I am afraid nothing will come from the stalks. However, next year, we will have a better garden & richer earth, & I hope you will be able to raise something for us to eat on the table.

They have almost covered the roof of Memorial Hall with joists, & I have no doubt that before you return they will have begun to board it in.

As I was going through the streets the other day, I saw a small waggon just like a butcher's waggon with a dog hitched into it, & on the outside was painted in large letters Tommie Brewer Jr. There was a boy in the waggon whom I wanted to tip out as I saw he was too heavy a load for the dog to drag — which was too bad.

Molly & Susy have gone to New London where they will stay till the middle or end of next week so the house is very empty again, & with everybody away it seems quite lonely.

Did you get an *Every Saturday* I sent two days ago with a picture of a country school in it? I thought you would like the pictures, but I did not read what there was in the paper. There have been several alarms of fire this week, but not one has come from old Cambridge.

I hope you will be careful not to get another fall from the horses or anywhere else. When you wish to look down upon anything under you, you must take care to hold on fast & not lose your balance. When I came out of Boston yesterday, I saw some boys on the top of the drawer of the bridge & one of them was sitting on the iron rod which goes across the upper frame work. He went through a lot of antics like the men at the circus up in the air, but he took good care to hold on fast.

Give my love to Aunt Alice, Aunt Mary & cousin May.

Aff'y, yr. Father

<div style="text-align: right">

In the tent at the Glen
Aug. 27, 1871

</div>

My Dear Jeffie,

 I wrote to your Aunt Alice last week to say that we had got well settled down in our tents, but then we had had nothing but intensely hot weather, making it very unpleasant to be obliged to do our work in the hot sun. Our camping place is a very nice one, & we are all well-contented with it. The first day we had all our things brought up from Gorham in a cart, & stopped as nearby as possible to the place where we were to stay. But as we had not time to clear a place for our tents, we put them up on a field nearby, & had a nice large fire built against some stones, around which we sat in the evening. The next day we began cutting away the bushes among the trees & set up the tent which is used to eat in & also to sit in at other than mealtimes. Our two sleeping tents are surrounded by trees, except on the side of the entrance which looks towards the river. The two tents are by themselves, each in its own clearing, though not far apart. The floor of mine is covered with brush & on it there is the sack which I brought from home, filled with straw. This makes a very nice bed, so comfortable that I find my camp bed unnecessary & have rolled [it] up & shall not probably use it again. In the other tent your Uncle Morrill, Little Morrill, Uncle Edward and Mr. Wolcott sleep. I have built two long beds made of posts driven into the ground, onto which long poles are fastened, & the poles have some strong cords passing backwards and forwards instead of a sacking. These support the straw beds, & which are very good ones. The cooking stove is in front of the tent where we eat, & there are some rough board shelves for holding the dishes & stores. Now that we have got everything arranged, all goes in very well. As we have no ice chest, we have arranged a place under the shadow of a large rock to put the milk, butter & meat, the milk and butter cans resting in the water. The river tumbles over large stones & rocks here, keeps up a roaring sound all the time & is very pleasant to sit by under the shade of the large trees on the banks. It has been so hot and dry that we have been wishing for rain ever since our camp was finished. Yesterday it began to be cloudy & last night the rain began to fall & continued to do so more & more until we went to bed. It was quite nice to hear it thump on the outside of the tent & at the same time to feel it could not get in, & that we could sleep through the night perfectly dry. About midnight it began to thunder, the rain to fall in greater quantity & the river began to roar louder than ever. When we first looked out this morning, we found that it had risen several feet & was nearly up to the

cooking tent. But the worst of all was, what do you think? The water had risen high enough to wash away all our stores from the cool place under the rocks. All our salt pork, butter, and leg of lamb which we expected to have today for our Sunday dinner were gone. The milk can was found some distance down the river with the cork in, but all the milk was out & its place taken by water. The tin butter box was found too, jammed between the rocks, the cover open and every particle of butter washed out. As to the pork & lamb, we have seen nothing of them & fear they are gone forever. It was rather a shabby trick the river played us but we shall know better next time & learn as Robinson Crusoe did to make preparations for storms in season & look out for surprises. Molly and Susy came down with little Anstace soon after breakfast, in the rain, to see with their own eyes the water rushing over the rocks & the place from which it had so treacherously carried off our provisions. Before the rain we thought of camping in a very nice place on the other side of the river, which last we could cross either on the dam or on the rocks. If we had set up our tents there we should have been completely cut off, as the water flows over both rocks and dam, making it impossible to cross on them.

However, the rain has stopped falling & I suppose the river will soon begin to settle down to its old level. I hope now that we have got rid of the dust we shall soon have cooler weather, which will make everything more pleasant still in this very delightful place.

I hope your beans and potatoes are getting on very well, but if there is no rain, they should be watered often if you wish them to grow.

Molly & Susy send their love to you & Aunt Alice & I add mine to theirs.

<div align="right">Affect'y, yr. Father</div>

The Glen
Sept. 3, 1871

My Dear Jeffie,

I believe I have not answered your letter, at any rate, as I am writing to your Aunt Alice, I will not let you go without one. I am glad you like Mortimer Ready. I, too, like all that I have read of it better than Swiss Family Robinson, because what is said in the first is nearer the truth. I hope you will like your reading book, & what it says about the sun, better when you come to understand more about it. Your potatoes must have been quite a pleasure to you, as they were your own raising. Next year you shall have a larger & better garden & no doubt you will be able to raise many more & much better things.

We have had a very warm day today & this afternoon my tent has been overrun by a swarm of ants that have come out of their nest, all having wings & flying about like bees in every direction. They keep their wings for a short time only & then bite them off, go into new holes & stay till next year, just as bees go out of their hives to find a new place when the hive gets too full. The nest was just under the edge of my tent, so that I thought of getting some hot water to scald them out, but concluded to let them go, as they did me no harm & amused me for some time watching their movements. This was the best thing to do & I am glad I did it, for it is only cruel to kill things that do not hurt or annoy one.

Molly & Susy went to ride yesterday afternoon with a waggon full & came back in the evening singing & shouting in the merriest manner possible. They have gone again this afternoon & all are coming down to the camp to tea. We are to have waffles, which Mr. Wolcott is making, & we expect that we shall have something very nice. The River has gone down again as low as when we came, but we have found nothing of the lamb or pork, nor of little Morrill's clothes which he put into the river to soak. A mouse has come to the tent to live & no doubt gets a plenty to eat as there are many crumbs & scraps of meat laying about in every direction. A striped squirrel walked through the large sleeping tent yesterday and seemed to be quite at home. I should be very glad to see more of them & should do all I could to encourage them, if they could only be induced to stay.

They are, however, too shy to stop long on so short an acquaintance.

With my best love,
Aff'y, yr. Father

Savannah, Jan. 28, 1872
Sunday Morning

Dear Jeffie,

As I have written to all the others, to Susy from Washington, Aunt Alice from Richmond (where I gave the letter to a policeman to mail) & to Molly from Florence, S. Carolina, this letter, of course, belongs to you. I hope by this time you are almost well again and that you will soon be able to go out as usual. We came here last night & in a very heavy rain with thunder & lightning, & today it is still unpleasant. But we have come to a much warmer place than Cambridge & as I walked round the town today I saw violets in bloom, hyacinths, & other flowers all growing in the open air. This seems very strange after leaving everything so dried up and withered at home. As there is no going farther south before tomorrow, I am very glad to stay here and rest, for two days & nights in the car is hard work. Tomorrow morning I start in company with Mr. Forbes and his party for Florida, where I hope to be after passing one night in the steamboat. How should you like that? We shall go only a short distance out to sea, so I hope not to be seasick. I hope you will write to me quite soon & tell me how you are getting along, & whether you have begun to read again. Ask Aunt Alice to send me through the post office one of my pamphlets on the *Fresh Water Shell Heaps of Florida.* She will find them in the lower part of the farthest book case on the left-hand side of the study (as one goes in). The weather is all clear again & as I walked out this afternoon I heard the frogs peeping. Give my love to all.

Aff'y, your Father

Hibernia, Feb. 3, 1872

My Dear Jeffie,

As this is your birthday you must have a letter from me, if nothing else, to remember it by. I hope by this time you are quite well again and have escaped the whooping cough which some of the other boys have had to follow after the measles. As I have thus far had no letter from home I am quite anxious for the first one, to know how all are getting along. As a mail comes today I have no doubt it will bring something.

We thought yesterday that warm weather had come for good, but this morning all is changed again & we have a cold & chilly northwest wind, making it very disagreeable to be out of doors, & so I am rather glad we have not gone into camp. We shall not go until next week, for the man who is to take Pompey's place with us has not yet come from Jacksonville, but we expect him today. The dog Smoke is here & all ready for a start though I suppose going or staying makes but little difference to him, but when he is out in the woods he has rather more freedom in running about. There is but little for us to do here at Hibernia except walking along the river & through the woods, & this we soon get enough of. Besides, after the great rains which have lately fallen, the ground is wet so that one wants rubber boots to go about in. I went out this morning to see if I could find some flowers for you, but have only this little white flower & violet to send. Last year I sent several & could have sent many more if the letter would have held them. So you see, the weather is unusually backward. Last year we were already in our first camp at Horse Landing, but shall not be there until about a week later. I shall be very glad when we pitch our tents for the first time & build our camp fire & cook our meals & eat them under a large tree. It will all seem very natural as it is the fourth time Mr. Peabody & I have done the same thing here in Florida.

I hope your birthday will go off very pleasantly & I will, at any rate, try to think of you as well & having a good time.

With best love to all,
Aff'y, your Father

N. end of bay
Rawling's Pond – 1865

Old Town, Feb. 20, 1872

My Dear Jeffie,

As we shall leave this place tomorrow morning & I shall pass the post office at Hawkinsville, I cannot let the opportunity pass without sending you a few lines. I am sorry to say that the letter you wrote me has not been received, but I hope I shall find it at the office tomorrow. If not there, I am afraid it is lost.

We are having pleasant weather but it is still rather cool, as an offset for which we are less troubled with mosquitoes. We have had a pretty good time here though there is much less game than last year. Yesterday & today Mr. Peabody shot 11 wild ducks which ensure food enough for a few days. We hope for better luck at the place we go to tomorrow, which is about 12 miles above this.

Smoke seems to enjoy himself & is always on the look out when anything strange comes along. Last night he waked us up in the middle of the night, barking at something which he heard among the trees, but which turned out to be an old cow who wanders about the woods here. Smoke was untied and he drove her through the bushes at a great rate, making a great noise as she crashed through the leaves and branches. A big alligator was killed yesterday close to the camp. He was an old fellow who seemed to have been through the wars, as he had lost a part of his tail & had a large lump on the top of his upper jaw. Mr. Peabody shot him with his rifle through the head & thought he had killed him, but when Adam went after him to get his teeth, he found the alligator swimming about, & crashing out of the water. He left him until today, when they made another attack upon him & this time they killed him. He was 11 feet long, had very large jaws & teeth & was a very ugly-looking fellow.

We are having fine moonlight nights now, & as I lie in my tent I can see the shadows of the leaves on the canvas.

Give my best love to all & hoping you are quite well again.

Aff'y, your Father

Old Town
Mar. 2nd 1872

My Dear Jeffie,

Four days ago I got a good number of letters, two from you & one from each of the other members of the family. The ones I supposed were lost have all come. I am very glad to get your two as they were both wholly written by yourself & show that you have improved in writing very much. Yesterday I received two more letters, one from Aunt Alice & one from Susy, also a letter from Switzerland. So I am very well off. I hope I shall have another letter from you soon. I do not remember anything about the mittens but hope you have not lost them & trust before this they have been found again. If not, I think you had better have a new pair.

Smoke gets on very well, though Mr. Peabody thinks he eats too much, which makes him lazy. For when he goes out to hunt Smoke has a good deal of work to do, in running after and bringing in the birds when they are shot. Sometimes he goes into the bushes & drives the birds out so that they can be shot as they fly up. Smoke is a very well-behaved dog & doesn't do anything he is told not. He is allowed to have anything to eat that he can find lying on the ground, but nothing that is on the table or in boxes. Though the things he is forbidden to have are within his reach, he never touches them. When we came up on the steamboat, a leg of mutton was hanging just over his head, but he stayed under it all night & he never took even a bite off of it. When we eat our dinners, he sits by & looks on, watching every mouthful, & acts as if he would like to have a plate & something to eat like the rest. When it comes night, he is put into the tent where the boxes containing the things to eat are, because sometimes the possums & coons come around the camp & if they can get a chance, steal all the meat they can find. One night a possum got into the box where the meat was, when Smoke barked & then Mr. Peabody got up & caught Mr. Possum by the tail, who forfeited his life for stealing.

Yesterday we left Blue Spring to come back to this place. There was a shower in the morning & it cleared off so that we felt sure of a pleasant day. But soon after we left, it clouded up again & before we had gone far it rained quite hard & continued to do so for three hours. After we came here, we were obliged to wait nearly an hour for the rain to hold up so that we could pitch our tents. At last we got everything all snugly under cover, Adam built a good fire & we had our dinner. It was still very warm & uncomfortable & we felt pretty sure that the weather was not settled yet. After we had gone to bed,

the wind began to blow harder & harder until at last it made the greatest roaring through the trees that I have ever heard. To make all things sure, I got up & drove the tent pegs in tighter, lest the tent might be blown down about my ears. Then I wanted to find some more pegs to fasten the front but it was pitch dark & I had to wait for the lightning to light up the ground so that I could see where they were. Having got everything all right I went to bed again, but the wind & thunder made such a tremendous noise that it was some time before I got to sleep again.

With best love to all.

Aff., yr. Father

Osceola Mound
March 10, 1872

My Dear Jeffie,

I was very glad indeed to get your letter of Feb. 15th, written all by yourself. I think you must be getting on quite well with your writing as this last letter is a great improvement on the others. You will no doubt soon be able to write quite nicely. I am glad you are able to go to school again & hope the weather will not be so unpleasant as to prevent you, as you were so unlucky as to lose so much time after you had the measles. I am glad, too, to learn that Benjie is all well again. I had not time to draw a picture of Smoke for your last letter, but sent one in my letter to Aunt Alice. We had a great thunder shower the night we came here & the lightning struck a large tree across the river & tore it all to pieces. They are lying about in all directions, some thrown to a great distance. If you had been here I have no doubt you would have thought everything was going to be smashed up.

Smoke is very well & is lying down under the tent where the stores are kept & where he is tied. As soon as he is let loose he runs around as hard as he can, barks, kicks up the leaves & makes a great to-do. But he very soon begins to look round to see if he can pick up anything to eat, & is generally very glad to pick up anything he can put his teeth to. He eats up turkey bones as if they were so much meat. Did you find your mittens? If not, I hope you have had a new pair.

Adam is at work making whistles out of alligator teeth & makes them very nicely, too. The tooth is hollow at one end & pointed at the other. My tent is now under two palms instead of orange trees as it was at Old Town where we last camped.

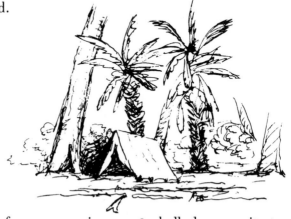

I hope to hear from you again soon & shall always write to you in your turn. With best love to all including yourself.

Aff'y, yr Father

Blue Spring
March 14, 1872

My Dear Jeffie,

Yesterday I received five letters, one each from Aunt Alice, Susy, Molly, & yourself, then one from Professor Cooke. I was very glad to get yours, & at the same time was very much amused with the piece from the newspaper about the comet. You must recollect in the first place that a newspaper is not to be trusted for any story of that kind, &, secondly, that nothing of this sort could be seen at Geneva, where the story is said to have come from without being seen at this same time in other places, which it does not appear that it has. The story is one of the kind we see every little while, got up to hoax people. You will probably never hear of it again, as it is all nonsense.

We left our camp down the river yesterday & reached this place again after a few hours travelling in the boat. The weather today is very warm again. This morning Mr. Peabody went out before breakfast & came back with two wild turkeys which he had shot. He shot a third but could not find [it,] so he came home for Smoke [and] took him in his boat to the place — but he was a long while in finding him & thought the turkey, being only wounded, had run off. But after a while he heard a great noise in the woods & then he knew that Smoke had found him. He went to him wading up to his knees in the water & soon discovered Smoke holding the turkey by the tail. Now we have three turkeys, all hanging up, which will last us for meat for several days. So you see Smoke, like the dog in the story you were reading, is a very useful animal. With best love to all.

Aff'y,
yr Father

Blue Spring
29th March 1872

My Dear Jeffie,

 I was very glad to receive your letter of March 12th. The next time you write, you can let the letter come in the envelope with your direction on it, only try to make it as well as you can.

 You must be pretty well-provided with mittens now as you have both the new and the old pair. By the time I return I suppose the time for using them will be gone by, unless winter lasts a great deal longer than usual, which I hope will not be the case.

 We shall remain here at Blue Spring until next Tuesday (today is Saturday), when we shall take down the tents once more & start to go down the river, & each time we move will be nearer home. We hope to reach Hibernia in about a week from the time of starting, but may be a few days longer. We have nearly a hundred & fifty miles to go, all in the boats, & shall stop at few places on the river. We have had some very hot days but generally they have been quite cool & comfortable, though there has been much more rain than last year.

 I hope you have had good weather enough to be able to go to school again, & that there will be nothing now to prevent your going regularly. You must try to get all fours, at any rate, for conduct. If you do try, I have no doubt you will succeed in getting the highest marks, which will make us all very glad.

 I hope you have read every day & have improved in reading very much since I went away. Of course, I mean every day that you have felt well enough to read. Do you see that the newspapers now say that the story of the comet was all nonsense & that they all make fun of it? So the next time you hear such an account of what is going to happen you won't think anything about it. The same thing has been said a great many times before & if the saying had come true, there would at this time be no world for anyone to live on.

 With love for yourself & all.

Aff'y,
yr Father

50

Hibernia, April 29 '72

My Dear Jeffie,

I was very glad to receive yesterday your letter written & directed with your own hand. I am very glad, too, to know that you read every day & have learned nearly the whole of the multiplication table. I have no doubt you will soon master the whole of it.

I wrote to Susy yesterday, but forgot to say anything about the garden tools you mentioned & wish to buy. I write this on purpose to say that you can have them whenever you like, on condition that you will always bring them into the house after you have done using them instead of leaving them in the yard.

I have just been down to the steamboat to engage my stateroom, & shall leave here tomorrow for Jacksonville, go from there to St. Augustine, and thence to Charleston. From Charleston I go in the cars to Washington, where I shall spend perhaps a couple of days. I expect to find letters there & shall write to say what day I may reach home.

We are having very fine weather here now, though today it has been rather warm. We have green peas every day, & blackberries on the table morning, noon, & night. We have had strawberries once only. Smoke enjoys himself doing nothing, except going down on the wharf to see the steamboats come in.

Nearly all the boarders have gone from here & after tomorrow there will be but three left. It seems quite lonely & I am very glad to feel that each day will bring me nearer home. It seems as if it were much farther from here home than from home here. My trunk & boxes are all packed & it will be pleasant to see the party on the way again.

There is an opossum here that has nine young ones, all of which she carries in a bag on the front of her body. They sometimes come out & crawl around on her hair, but when they get larger, they will go on her back & fasten their tails around hers just as you can see in the book of animals. There are many snakes here but only two are poisonous, & these are quite scarce. The flowers are very abundant & young oranges are growing quite fast.

With best love for yourself & all.

Aff'y, your Father

P.S. Jacksonville, 5 P.M.

Left Hibernia at 9 o'clock and go to St. Augustine tonight.

51

Cambridge, July 28 '72

My Dear Jeffie,

I was very glad to receive your letter & to learn that you were having a pleasant time. As nothing is said about your cough I hope that has entirely gone. Your vegetable garden is doing very well. The tomatoes have had many more blossoms, & I have no doubt when you come home you will see young fruit, though it is probable that many of the flowers will not come to anything.

The beans grow well. I have put up a taller stick for them to climb upon, as they were running about among the tomatoes & potatoes. Two vines seem to be running a race to see which will reach the top of the stick first. The one that started last seems to be gaining on the other. They grow between one & two inches a day. I shall soon be obliged to put up one of their poles from the cellar as the one they now have is not long enough. The potatoes seem to be flourishing, but I have not yet looked to see whether there are any young potatoes in the ground. The men came with the coal on Friday, so that job is all over. As it rained all day there was no dust, but the men got pretty well soaked. Molly came home yesterday & Susy went into Boston to see Florence Elliott sail. Susy made her bed & dusted her room before breakfast that morning. Wasn't she smart?

I have been to the house in Brattle St. this afternoon & find it all safe, though it has been broken into once since you went away. John Ting's boy & some others whom he brought into the yard did it — by breaking the window fastening in one of the kitchen windows. They went all over the house but did not carry anything away or do any mischief as far as I know. I went to Ting's house & told him if his boy was found in the yard again I should send the police after him, so I do not believe we shall have any more trouble with the boys.

It is a nice cool day here, but I suppose it is much colder in Princeton & that you are wearing your thick clothes, for we almost need them here.

As you have been (in P.) more than a week you know pretty well by this time how you like it. When you write again, which I hope will be soon, tell me what you do for amusement & whether you have caught any more fish.

With love to Aunt Alice, Aunt Mary, Benjie, & yourself.

Aff'y, yr Father

My Dear Jeffie,

Your very nice letter sent last week was received on Saturday, & I should have answered it long ago if I had not been so busy & felt tired when night came. I hope you will write again soon. We are now having very hot weather, as much so as in July, but I hope it will not last as long, for we are almost roasted today with the thermometer up to 90.

They have been cutting down more trees between us & the next house, one of which fell into our yard & came very near destroying your garden. As it was, the tomato vines suffered from the tree falling on them, but they are now getting up again & I hope no permanent injury was done them. I gave the man a good scolding but that was of no use, for the mischief was already done. The beans are doing very well. No. 1 has got a little ahead since I last wrote to you, & both have many blossoms.

We have heard from Susy twice & she seems to enjoy Biddeford Pool very much. Cousin Julie has been here & says you are enjoying yourself very much at Princeton, which I am very glad to know, & that you have thus far escaped being sick or having a cold.

Have you learned to milk yet well enough to fill a small pail, or do you content yourself with looking on? Your Uncle Edward once tried to milk a cow when he was a boy, & as he was nearly through the old cow gave a kick & upset him, the milking stool & the pail, so that all his labour was lost that time. In Switzerland, the milking stools have only one leg, so that they have to look out pretty sharp not to capsize & spill the milk. Do you think you could sit on a bench on such a stool & milk a pail full without pitching over? Do you still go fishing & how many kinds do you ketch? Look out for the horned pouts, for if they prick you with their spines, they sometimes make a bad sore. But I suppose by this time you have learned how to take them off the hook.

Tell Aunt Alice her Sunday letter came in good time & I hope to hear again from her & you soon.

Give my love to Aunt Mary, Aunt Alice & Benjie, & with love for yourself.

Aff'y, your Father

Gorham Hill
Aug. 30th '72

My Dear Jeffie,

Day before yesterday I received a letter from your Aunt Alice enclosing one from you & yesterday another enclosing the key which was the right one from my trunk. You had better be careful about going on top of the old shed, for the boards are much decayed & may let you through. You say nothing about your garden & how your beans, tomatoes & potatoes are getting along. Isn't it about time for some of the tomatoes to turn red and the potatoes to be ripe enough to eat?

We have a rainy day here, & nobody goes out of the house. Thus far, however, the weather has been very pleasant for the most part, but the rains have been just enough to make us glad we did not go into camp. Mr. Hodgdon got in the last of his hay yesterday just in time to save a soaking today. The barn is well filled now with hay & oats & it would be a very nice one to play in. I have not yet seen the cows but they give plenty of good milk, which is all I want of them.

There is an old school house close by with benches for about twenty scholars. The seats are not so good as you have at Miss Somers, but are made of rather rough boards, & I don't think you would like to sit on them through a whole forenoon. Then they are very badly cut up with names & notches. I noticed that the names were nearly all girls' names, & as girls don't cut benches, I suppose the boys did it. The other night (the school house is always open), a lot of boys with an accordion went in there & sang and pounded the benches. As they had no lamps they set fire to pieces of newspaper on the top of the benches, some of which were a little scorched. They seemed to have a very lively time & no doubt enjoyed themselves very much.

I am sorry to learn that Aunt Emmie is not well but hope she will be better as soon as she gets quietly settled down at home. Give my love to her & the others in Ash Street & to Aunt Olive.

With love for yourself, Aff'y, yr Father

My Dear Jeffie,

It is certainly your turn for a letter, especially as you have written twice since I have written to you. I am glad to hear that you got so good a supply of potatoes, but I believe another year you will be able to do a good deal better. The potatoes as well as the tomatoes were planted too near together; the tomato plants should be at least three feet apart, so as to let each vine spread out without interfering with the others. They try to raise tomatoes here, but the summer is so short that they almost never ripen. Mr. Hogdon has some planted but they have not yet begun to turn red.

I am very glad you are going to Miss Harris' school, for I believe you will have a much better time than at Miss Somers' & have a much better school room. It will be so much better, too, to be with more boys. It will be nice to have the Fisk boys to go & come with you.

You did not tell me what you bought your chair for; I am sure it was very cheap.

I am all alone here just now. Your Uncle Morrill has gone on an excursion through the mountains to see people with the hay cold, & Morrill Jr. has gone on foot in the same direction until he meets him. I expect them both home tomorrow. I amuse myself by walking round the neighborhood. The weather is very pleasant now & we have no mosquitoes. Today ends the third week that we have been here & in eighteen days more it will be time to go home again.

You asked if you might cut down one of the dead trees. You can do it if you can get it out of the way after it is down. If it is a large tree, you had better not try it. I do not know which tree it is you refer to. Tell Aunt Alice I was glad to get her letter & to know that Aunt Emmie was better again, & I hope she will enjoy her visit out west very much.

Please ask Susy to look in the lower part of the book case furthest from the door & see if she can find among a pile of Peabody Reports one for the second year, & if so mail a copy to The Boston Public Library. They have asked for one in one of the letters I have received. If she can't find one, it must wait till I come home. There are plenty of two cent stamps in my locked drawer. She can put in the corner on the outside — *From the Peabody Museum.*

Give my love to all & with love for yourself.

Aff'y, yr. Father

Old Town, St. Johns River
Florida, Feb. 3rd 1873

Dear Jeffie,

I wanted to write a letter which would leave here on your birthday, but the mail did not suit & so I must wait a day or two before this leaves Old Town. We have been here four days & passed two days on the way. The last were far from being comfortable. The weather was pleasant when we left Hibernia in the steamboat, but before night it began to rain. The boat passed the place where we [were] to get off with our boats etc. at four o'clock in the morning, when it was quite dark & still raining. At the landing was a small store with verandah, under which we hurried our things & sat down to wait for morning. Adam made some tea for us & picking up some wood got a fire, so that by seven o'clock breakfast was ready. As the rain continued through the day, we were obliged to stay on the verandah & as night came on it was pretty plain we should sleep there, too. Soon after tea we made our beds on the boards & in spite of their being rather hard, had a good night's sleep. The rain kept up through the night, but as it did not blow in under the piazza we were quite dry. The next morning it again seemed very uncertain whether the rain would stop, but about noon it held up & we loaded our boats & were off. Before night we had our tents all set up at this place, six miles down the river from Hawkinsville. Adam build a fire against a large trunk of tree lying on the ground & set up a table, so that we were able to have our supper in very nice order. Since we have been here, the weather has been very pleasant, & yesterday & today rather warm. The thermometer at 3 o'clock was 72 degrees, & I am writing this letter at the front of my tent with my coat off. The trees are fast putting out their new leaves & the grass and other plants are springing up in all directions. The alligators are just beginning to crawl out of the river to sun themselves. While rowing up the river this forenoon, I saw nearly a dozen of them & shot two with my rifle. Mr. Peabody goes out every day to hunt, & has killed five wild turkeys, & some ducks, thus securing us an abundance of good food. Smoke is here, too & does his share in hunting & in keeping watch by night. He sleeps in the tent where the provisions are, & if any wild animals should attempt to steal anything he would be after them quite soon. Our four tents, one for Mr. Peabody, one for myself, one for Adam and Charley, the boy & one for the stores, can all be seen from the river & make quite a show, especially when seen from the steamboat coming up. I enclose some violets, picked near the tent, in honour of your birthday, & wishing you a happy New Year, send you the very best love & the same to Susy, Molly, and Aunt Alice.

Aff'y, yr. Father

Feb. 5th: All well — no letters for ten days.

<div align="right">Alexander's Spring
Feb. 16, 1873</div>

My Dear Jeffie,

 I was very glad to get your two letters & to learn that you were well & able to go to school, notwithstanding the weather has been so cold & stormy. As you will see by this letter, we are no longer at Old Town. We left it three days ago after having had a very pleasant time there, but before saying anything about this place & how we got here, I must tell you how Adam caught the possums who came into the camp at night to steal our provisions. He drove a double row of sticks into the ground & placed between them a big log, which was raised about a foot at one end, the other resting on the ground.

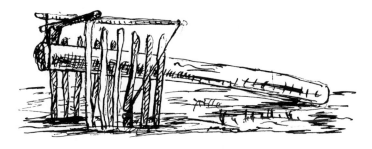

The upper end was supported by a string & this by the stick which rests on a cross piece. At the other [end] of this stick is a string going to a notch on one of the side sticks. A turkey bone was fastened to the string so that when the bone was pulled, the string was set free and down came the log on the possum . . .

 After leaving Old Town, we went down river to Orange Mound & stayed there overnight. As the weather was warm & clear we only put up our mosquito nets, but drove the pegs into the ground, so that in case of sudden rain we could pitch our tents in a very few minutes. The night passed off pleasantly, & the next morning we ascended (to) Alexanders Creek to a place called Dragoon Ford, where we slept again without tents & had a very comfortable night, too. Today is the warmest we have had, the thermometer standing at 90 degrees in the shade, but it is beginning to cloud up & we expect rain. Our camp is on the slope of a sand hill & is nice & dry & as good as any place we have been in. Near it the Creek, really a river, comes up out of the ground. The water is as blue & clear as possible. The fish swimming about, & the shells at the bottom can be seen with the greatest distinctness. There are a great many very old & large trees too, cypress and oaks; all the bushes in some places are covered with the vines of the yellow jasmine now

in full flower, & giving out a perfume which fills the air. Palm trees grow in great abundance, many of them leaning over the water in which they are beautifully reflected. We expect to stay here about a week, if there is hunting enough to make it worthwhile. I expect no letters or papers here, but trust there will be a good store of them when [we] pass Hawkinsville again.

With best love for yourself and all at home.

Aff'y,

yr. Father

Whooping Crane, from *The Birds of America*, J.J. Audubon, Philadelphia, 1842.

Huntoon Creek
8th March '73

My Dear Jeffie,

I was very glad to receive your letter of 22nd Feb., but if you were kept away from school because you were not well, I trust that before this you have gone again as usual. I told you in one of my letters about the trap in which Adam caught the possum. He has since caught more of them & we had one for dinner, stewed, & found it very good. We have tried *coon* once, but do not like it so well & shall not probably try it again.

The weather has been unusually cold & one morning the water in the bucket in front of my tent froze, as did Mr. Peabody's stockings, which were wet, *in* his tent. Today is warm & sunny. We find this place very much pleasanter for being off from the river & out of the sight of steamboats. There are a great many more birds here, too & in the morning they sing away as fast as they can from daylight to sunrise. There are great numbers of robins here & when they tune up in the morning, it sounds very much like spring with us at home. Most of the birds are quite different from any we see in the north, the largest is the *Whooping* or *Sandhill crane* which stands five feet high. When he blows his trumpet in the morning, he can be heard for miles around. The nicest, however, are some little birds that call and answer one another in the sweetest notes you can imagine, & keep it up half through the forenoon.

I will now say what I ought to have said before anything else, how glad I was that you got a reward at school. It pleases all who love you to know that you were doing well, so much that I hope you may have another soon. I do not wish you to do well for the sake of getting the reward but because you like to. To do the best you can in anything you undertake is the surest way of making yourself contented and happy. Everybody likes a boy that does, & no one a boy who does not do well.

We shall leave this place tomorrow morning for Blue Spring where I hope to find some more letters. Just after I mailed my last letter, to Aunt Alice, I received one from her dated Feb. 26th with two newspapers of Feb. 1st! This last having been nearly five weeks on the way.

With best love for yourself and all.

Aff'y, yr. Father

Monday morning
10th March 1873

We arrived here yesterday & have got our tents set up, & everything in good order. Two parties were camping here when we came, but neither of them, fortunately, in places we have been accustomed to occupy. One party left this morning & we hope the other will go soon, as (it) takes away much of the pleasure to have strangers near by. But so it is, the river is so much frequented now that one must make up his mind to put up with such and many other unwelcome changes from the old ways when we first came here.

Yesterday was rather warm when travelling, but this morning is cool and fresh.

The Neilsons come tomorrow & we expect a good mail by them as they will bring all the letters & papers which have accumulated for the last few days — when I hope to hear good news from home.

Blue Spring
Sunday, March 23rd '73

My Dear Jeffie,

I have been hoping to get some letters from home for the last ten days, but the last mail brought only one. That one was from Mollie & dated 8th March, having been more than fourteen days on the way. I suppose the trouble is in the post offices at Jacksonville & Hibernia & then it has happened several times that the burser of the steamboat has carried letters & papers up & down the river for two or three trips, although he regularly stops at this place at each trip. Up to this time I have had four letters written in March from Quincy Street. Another mail comes today, & I hope at least to have one.

We shall leave this place in a day or two, & begin to descend the river & so begin our journey towards home. The weather here has continued remarkably pleasant, we having had only one real rain which came mostly in the night. I have just been examining some Indian shell mounds on which the natives used to live & have found two places where they had probably eaten a human body just as the cannibals did, as you have seen described in your story books. Of course, only the bones were left, but these were cracked up in the same way that the bones of the deer & other animals used for food are. As they always have separate places to bury those who die in the usual way, it is most likely that the bones I am speaking of were those of one of their enemies killed in battle & whose flesh they had eaten in triumph and in celebration of their victory. The mounds are very old and the Indians who built them lived a great many hundred years ago.

Monday 24th: Yesterday brought us a mail with a letter from Susy & another from Aunt Alice & some newspapers. The letters were dated 9th & 13th, the last Susy's. Both having been rather long on the way — I hope soon to have another from you, for I am always glad to get one, & to learn that you have been to school regularly, & have done well. Tell Aunt Alice that her long letter was very acceptable & that I am sorry she had so much trouble with the cooks, but hope everything goes smoothly again.

Give my love to Susy & tell her that until she gets over these pains she complains of, she ought not to think of parties & dancing. If it does not rain today as it now threatens to do, we shall break up camp & go to Huntown which is down the river — & where we shall camp a few days.

With best love for yourself & all,

Aff'y,
yr. Father

My Dear Jeffie,

I was very glad to receive your letter this morning & am glad that you are having a nice time & enjoyed your ride on the top of the omnibus.

The carpenters are getting on rather slowly in the house, but the plumbers seem to be doing very well. The new pipes are nearly all in, the wash tubs are set in the back kitchen, & I hope the worst part of this work will be over quite soon, so that the painters & paperers may begin their work. When this is done the house will be ready for the furniture. We miss you very much & shall be very glad to see you at home again. The photographs of you & Benjie are quite good.

There is nothing new at home & as Aunt Alice has written to you I suppose she has told you how we are getting on.

Give my love to your Aunt Mary & to Benjie & with best love for yourself.

Aff'y,
your Father

Bethlehem, Sept 28th '73
Sunday

My Dear Jeffries,

I was very glad indeed to receive the nice long letter from you last evening, especially as you wrote so much more than usual & directed it yourself. As soon as I received it, [I] showed the outside to a gentleman standing by & said isn't that a little boy's handwriting — "Yes," said he, "he writes a good plain hand." I hope you will write again before I come home & tell me something more about the blasting of that rock. You only got so far as to say that Mr. Whitaker looked at it & scratched his head. I don't believe that scratching his head had much effect on the rock. I am glad, too, that you have attended to your reading & French every day, for that [will] help you when you go to school again.

We are having very warm weather here; yesterday the thermometer was 80 degrees, & today it was 76 at two o'clock. It is too warm to be comfortable & I suppose all at once there will be a change to frost & cold weather, when we shall be very glad of fires once more. The house is to be closed at the end of this week & so I shall start for home on Saturday at the latest, perhaps a day or two before. All the leaves of the trees are now in their most splendid colours, & bright red, yellow, scarlet & green are to be seen in all directions. Perhaps you had as good at Princeton, but they could hardly be more showy than they were here yesterday & have been today. I suppose the first wind & rain will bring most of them down.

You did not say whether you caught any partridges in your snares. They shoot many of them about this place, but I have started up only one, & that was when I was walking through the bushes. If I had had a gun, perhaps I might have shot him. There are a plenty of striped squirrels & quite tame. One of them came up on the hotel steps last evening, & when I was sitting on a log in the woods this morning, another came quite near to me, apparently to see what I was doing, but he concluded to go, I suppose, because he saw me cutting a stick, though it was not intended to do him any harm, but for a cane for myself.

As you start tomorrow for Cambridge, I direct this to Quincy Street, which is a pleasant thing to do as it looks as if this family were getting home again. I shall be very glad when I am there myself for I am getting rather tired of staying here. Give my love to all and with love for yourself.

Affectionately,
yr. Father

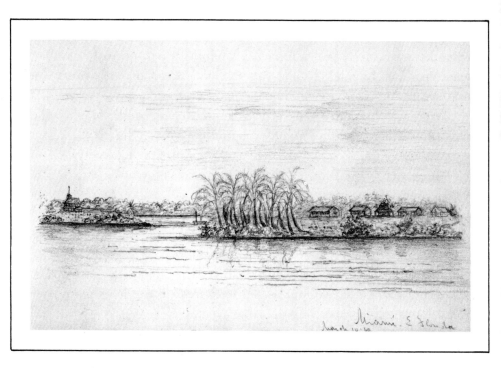

Miami – E. Florida – March 10, 1869

Hibernia, E. Florida
Feb. 3, 1874

Dear Jeffie,

Although I wrote to Molly yesterday, yet, as this is your birthday, I will send a few words to you. I have no doubt you are enjoying the day very much and will receive some presents that you like. I enclose a dollar which you can spend for anything it will buy, but would recommend that it should be something you can use or keep; you shall decide what. I see by the papers you are having very cold weather again & have thought you might find it rather disagreeable going to school. Such a difference between Cambridge and Hibernia — here the thermometer actually went up to 78 degrees yesterday & last night was uncomfortably hot and sultry.

We expect Adam today, & if he does not disappoint us, we shall start on Thursday for our camp. Everything is ready that can be, until he comes. It will seem quite natural to be travelling in our boats & sleeping in our tents again.

Smoke has come again with Mr. Peabody & goes down on the wharf every day, if he is untied, to see the steamboat come in. He goes entirely alone, looks at the boat & sees what is going on, & comes back again contented.

Tell Molly that the letter she forwarded came yesterday.

I hope to hear from you quite soon.

As the mail closes in a few minutes, I must stop here.

With best love for yourself and all the others.

Affectionately,
Yr. Father

Huntoon Creek, E. Florida
Feb. 19th 1874

Dear Jeffries,

By the last mail I had several letters, one from everybody at home except yourself, but I have no doubt yours will come the next time. I am glad to hear that you have had such a nice present from your Aunt Mary & hope by the time I come home again you will have learned to fiddle something. Did you get my letter with a New Year's present in it & have you bought something?

We are having very hot weather here. For the last week the thermometer has averaged 84 degrees in the shade in the middle of the day. I am writing this sitting in the open air under the shade of a palm tree. Yesterday I went down creek & saw an alligator asleep on a log & fired my rifle without hitting him, but the second shot killed him. He was about six feet long. Today, while I was walking through the woods, I came upon a black snake about seven feet long, but while I was cutting a stick to kill him he made off with himself. He evidently knew what was best, & I think I should have done the same, if I had been in his place.

We start tomorrow for Blue Spring where our letters will be sent hereafter from Hibernia instead of Hawkinsville. My newspapers, *The Tribune*, nearly all go wrong, for I have had but two since they were directed to Hibernia. I suppose the post masters steal them. I cannot account for their disappearance in any other way as they are very plainly directed. This is too bad, and I had depended upon getting them regularly. Mr. Peabody receives his *Adventurer* oftener, but still many of them do not come.

Tell Aunt Alice that I received the letter & wood cut from Mr. Hosmer, which was what I wanted, and have forwarded them to Mr. Winthrop. I am much obliged to her for attending to them.

With love for yourself & all.

Affectionately,
Yr. Father

66

On the Wekiva, Camp No. 2
March 11th 1874

My Dear Jeffries,

I was very glad to receive your nice long letter of Feb 17th & glad, too, that you have improved so much in your writing, which is certainly the case. I hope you were not the worse for sitting up so late on the night of Susy's sociable.

If you had a telegraph, where would you put it & to whom would you send messages? There is no other boy near enough to join with you in one, except perhaps Chauncey Smith. However, when I get home, perhaps we will arrange something in the house that will answer this purpose.

I had no time to write to you by the last mail, but sent two kinds of butterfly in an envelope which I hope you received in good order. If you moisten their bodies, you can straighten out the legs, & put the wings in the right position so that you can put the specimens on pins. They are the only two kinds I have seen but perhaps when we get back to Blue Spring I can find some others. It is not quite late enough for them yet.

Last night the alligators bellowed like bulls & some of the night birds made a great deal of noise. Our present camp is three miles below the one I last wrote from & just on the edge of a swamp. The weather has been very cool & pleasant, but today it has begun to rain. I hope it will not continue to do so long, for we want to start for Blue Spring tomorrow morning. It will take us nearly all day to make the journey. Turkeys are quite plenty here so that we have had an abundance of fresh meat. Yesterday as I was rowing down the river I saw a deer come to the brook to drink, but as soon as he saw me he gave a jump & off he went into the thick woods.

Have you learned to play any tune on your fiddle yet? I hope to hear you play something when I come, if it is only "the tune the old cow died of."

Blue Spring, March 12th

Another letter from you came today, which I was very much pleased to receive. I believe all you have written have come safely. If you have had but one from me, some must have been lost for I have written the same number to all & this just finished the round once more & shall begin again with a letter to Susy.

I suppose the cars which go up Mt. Washington are perfectly safe & if we should be near enough next summer, we will make an excursion to the top.

With love for yourself & all.

Affectionately,
Yr. Father

<div align="right">Blue Spring

March 15th 1874</div>

My Dear Jeffries,

I send this rattle of a rattle snake which a man killed near here yesterday. The snake was about four feet long.

<div align="right">From your Father</div>

Rattlesnake rattles, courtesy of G.E. Gifford, III. Photograph by Hillel Burger.

Blue Spring
Mar. 19th 1874

My Dear Jeffries,

I received two letters yesterday, one from you & another from Aunt Alice, both of which I was very glad of. Please thank her for hers, & for yours I thank you. It was a nice long one & very well written, & shows that you steadily improve in writing.

I enclose two butterflies, but they are both somewhat broken, as they were caught in a hat & knocked on the ground. If I had a proper net I might collect a good many, though thus far I have seen but three or four kinds. One of the two I send now is the same as those I sent before.

Yesterday as I went to my valise in the back part of my tent & opened the cover to the top part, out jumped a large black snake, about five feet long. He ran about the tent in a very lively way for a little while & shook his tail just as a rattle snake does. I caught him in my hand & whacked him against the tent pole which ended all his movement.

I hope the rattle of the rattle snake I sent you reached you without being broken.

The boat goes out of here usual time this morning & I am writing this on my bed to have it ready for this mail at half past seven, & shall write to Susy on Sunday. I wrote the last mail to Molly.

We are having very pleasant though rather warm weather now, but have thus far been remarkably free from rain. I believe it has only rained twice since we have been camping.

With best love for yourself & all.

Aff., Yr. Father

Blue Spring
March 31st 1874

My Dear Jeffries,

I was disappointed today in not receiving either a letter or a newspaper in the mail, which has just come, but I ought not to complain as in the last there were seven.

I hope the last butterflies sent in an envelope reached you in order. I send you some others with this, two of which are different from any which have been previously sent. Possibly I may get some other kinds & if I do, you must save them. Later in the season there will be many kinds, but I fear too late for me to collect them. I am very glad you take an interest in insects, for they will give you a good deal of pleasure if you take the trouble to learn something about their habits.

We are still having very warm weather, that is compared with Cambridge, but it makes life in camp very comfortable. It is beginning to bring out the snakes in considerable numbers. The other day five were killed in the camp and one of them had been eating turtle eggs. When I struck him, one came out of his mouth and, on cutting him open, I found three in his stomach. I have nothing special to tell you at this time. I wrote to your Aunt Alice by the last mail and shall write Susy by the next, after the one which takes this.

With best love to yourself and all.

Affect.,
Yr. Father

Papilio *Ajax* and Papilio *Huntera*, from *The Natural History of the Rarer Lepidopterous Insects of Georgia*, J.E. Smith, London, 1797.

Blue Spring
April 9th 1874

My Dear Jeffries,

I was very glad to receive your letter of March 16th to 22nd. It was very well written and shows that you are improving.

I do not know the names of most of the butterflies which are found here for I have never taken the pains to find them out, but will try to help you do so when I come home. I am glad you will be allowed to go into the Agassiz museum alone & hope you will behave very quietly there & will not do anything that is not proper.

I have caught some more butterflies which I send, & if, as they are the same as you have had before, you do not wish them you can give some to Gordie as he has given you a good many.

I hope to be able to get some more, but the ones I have sent you are all the kinds I have seen here.

I have found a good many cocoons, in former years, on the bushes in Vassal Lane, but as these have been mostly cut down, I suppose you will not be very sucessful there. The bearberry bushes often have cocoons — also the wild-cherry tree. The bushes around Fresh Pond are likely [to] have some.

With best love,
Affectionately,
Yr. Father

I have written to Aunt Alice by the same mail as this.

Hibernia, April 25th 1874

My Dear Jeffries,

I received yesterday your letter of April 18th, & today have one from Molly dated 19th. I was rather surprised to see them, as I had supposed my letter requesting that letters should be sent to Washington must have reached home before the last note from there. If it has not been received, I can only repeat the request that hereafter, until further notice, letters be sent to Washington. I have directed the *Tribune* to be sent to Cambridge but it still comes here.

It was very kind of Dr. Hagen to give you the butterflies & the box to put them in. When you go to see him I hope you will be careful to learn all you can, as he knows more about insects than anybody in the country. Since I left Blue Spring, I have not caught any more butterflies, as I have no net now. I borrowed the material of which this net was made at Blue Spring & gave them back again when I left.

I have seen one very beautiful species about here, but it flies very high & I doubt if I shall be able to take it without a proper net.

We have had a very strong wind blowing today & some rain with the prospect of more.

I expect to leave here for Washington on Tuesday (28th) or Thursday (30th) but will write again before I start. There are only two boats a week, to Charleston, that I would like to go in.

I wish I had some more butterflies to send you.

I am picking up all the things which are to be sent home by water & shall ship them to Boston.

I have no special news to send.

With best love for yourself & all.

Aff'y.,
yr. Father

My Dear Jeffries,

I suppose that you have come to feel quite at home in Gloucester. I hope you're having a very good time enjoying everything. I hope to receive a letter from you telling me what you are doing quite soon; how many fish you catch & how many butterflies.

I caught a nice large moth in Brattle Street a few evenings since. As I was walking along the fence, I saw something bright, & when I got up to him, found it was a Polyphemus, of which you already have one specimen. I have saved it for you. Saturday I found a box at my laboratory, which came from Kentucky, & had two live rattlesnakes in it. [I] have not opened it yet, but every time it is shaken they set up a great rattling. The sound is very much like that of a locust.

I have just received your letter and am glad you are having so good a time. The whale must be rather *old* to smell as strong as you say. There is no objection to your fishing off the rocks if you wish, or to going in the boat if your Aunt Alice thinks he is safe & knows how to manage the boat.

Give my love to your Aunt Alice & Aunt Mary and all and love for yourself.

Aff.,

Yr. Father

Polyphemus Moth, from *A Treatise on Some of the Insects Injurious to Vegetation*, T.H. Harris, Boston, 1862.

Bethlehem, Aug 30th 1874

My Dear Jeffries,

 I have been hoping to receive a letter from you & hope I shall soon. We are having the pleasantest weather possible & thus far no rain, though this afternoon there was a heavy thunder shower on Mt. Washington & the clouds in that direction have been very black. I went to the Strawberry Hill House this morning to see your Aunt Lizzie & Maudie, & went to church with them at the Sinclair House. I saw your cousin Charles at Mrs. Turner's as I went by & he inquired for you.

 I hope you had a good time at Newton, got some butterflies, and otherwise enjoyed yourself. I haven't heard a word from either Molly or Susy, though Maudie had a letter from Molly yesterday saying she was having a very good time.

 Monday, 8:30 p.m. The mail has just come with letters from Molly & one from Aunt Alice enclosing one from Mrs. & Dr. Baird. I am glad you had so good a time at the farm. It has been very warm here today, & there are many fires in the woods. Two evenings ago there was a grand fire in the mountains opposite Bethlehem & the smoke rolled up in a grand cloud. This afternoon it is so smoky that the distant mountains can hardly be seen. I have had no signs of my hay cold since I have been here.

 With love for yourself & your Aunt Alice.

 Aff'y,
 yr. Father

No Proof Has Come —

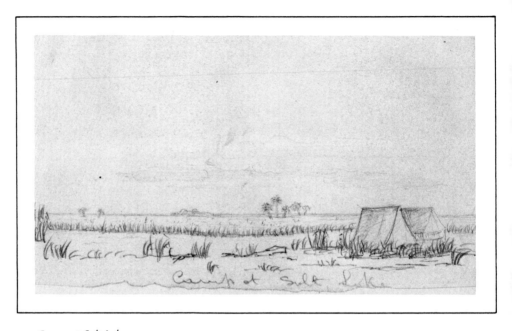

Camp at Salt Lake

EDITOR'S ANNOTATIONS

ANNOTATED NOTES FOR THE LETTERS

Letter 1, page 1 — Alexander is in northern Maine about 20 miles south of Calais. The birds which Jeffries Wyman describes are an osprey and a bald eagle. In *Birds of America*, the following passage appears in discussing the bald eagle:

> *Frequently he is seen soaring high in the air in search of something to eat. . . . most of his food is dead fish gathered from the surface of the water but when he cannot find the dead fish he often robs the osprey compelling it to drop the fish it has just captured.*

Birds of America, Editor-in-chief, T. Gilbert Pearson, Garden City Publishing Co., Garden City, N.Y., 1936, Part II, p. 81. Jeffie is now two-and-a-half years old.

Illustrations — The drawing of Rawling's Pond is dated the same day as the letter. "Island of Great Expectations" is dated August 22—23, 1863. It is included with this letter because the following passage appears in Jeffries Wyman's diary for August 23, 1866: "At 8 went to 'Island of Great Expectations' to watch. E. 'put out' Point on E. Side when he immediately started on a track. Watched in vain as Annie & I did three years ago." (Annie was his wife who died shortly after Jeffie was born.)

Letter 2, page 2 — Palatka was an important port on St. Johns River. By 1840 boats regularly carried passengers and freight between Palatka and Jacksonville."Great Honour Day" refers to Jeffie's birthday. He was three years old. Aunt Alice cared for Jeffie because his mother had died. Susy and Molly are Jeffie's half-sisters. In his diary for February 3, 1867 is the following entry:

> *Jeffie's birthday. Wrote him a letter & sent him some flowers picked in the open air. God bless & keep him & may he live a good life. Wrote to Mrs. Wheelwright. Walked about the town & its neighborhood. A breast work thrown up by the Union troops surrounds it. Walked along the shore in search of pottery & c. Palatka rests on a shell mound several hundred yards in length on the river side, where it is fully exposed. The bank is about 12 ft. high, & consists of fine silicone sand – except for about 3 ft. from the surface where it is largely mixed with shells chiefly Paludinae, next but less numerously with Ampullarias. Unios or Anodontas were also found. These shells are not found far back from the river since there are no signs of them in the Union breast works. Neither are they found above or below the town as the ravines at either end are free from them. They would only have been deposited under water, & therefore indicate a former elevation of the land – Numerous fragments of pottery were found in the debris of the banks, but probably were left on the surface by the Indians. Bones of the alligator – southern end of the town, beneath roots of a large oak tree, I found some bones of the hand & foot of a human skeleton – They belonged to two different individuals one of small size though adult, apparently a female – They were beneath the shell layer or just below the bottom of it – There was no appearance of fresh earth having been disturbed as in digging a grave. & no other bones could be found in the debris of the bank near by – Two flint flakes were also found.*

Illustration on page 4 is Black Hammock. For information on that site see: Wyman, Jeffries, *Fresh-Water Shell Mounds of the St. Johns River, Florida* (hereafter abbreviated as FWSM), Salem, Mass., Peabody Academy of Science, 1875. With a new introduction by Jeremy Sabloff, AMS Press, Inc., New York for Peabody Museum of Archaeology and Ethnology, Harvard University, Cambridge, Massachusetts, 1973, pp. 4, 41, 42.

Letter 3, page 5 — Enterprise is on St. Johns River, Florida on the north shore of Lake Monroe. See: *FWSM*, pp. 19—22.

Letter 4, page 6 — Jeffie is away in "the country" — Billerica is about 20 miles north of Boston.

Letter 5, page 7 — E. Eden is on Mt. Desert Island, Maine. The mountain mentioned is Cadillac Mountain. See: *Maine: A Guide 'Down East,'* written by Workers of the Federal Writers' Project of the Work Progress Administration for the State of Maine. Houghton Mifflin Company, Boston, 1937, pp. 282—284.

Letter 6, page 8 — Jeffries Wyman is on his way south to Florida.

Letter 7, page 10 — The concern about whether the weather is suitable for his return, refers to his respiratory condition which necessitated his not being in very cold temperatures.

Letter 8, page 11 — Jaffrey is in southern New Hampshire.

Letter 10, page 13 — Regarding wolf-fish and fool-fish, see: Perlmutter, Alfred, *Guide to Marine Fishes*, New York University Press, New York, 1961. Wolf-fish, p. 402. "Fool fish" is probably the American Goosefish or Angler fish (*Lophius americanus*, Cuvier and Valenciennes), pp. 413—414.

Letter 11, page 15 – Fernandina, Florida is north of Jacksonville. In the 19th century, it had an important harbor.

> *The small Laughing Gull follows the great Pelican and hovers above the spot where it plunges. The Pelican soon emerges, holding the fish, which it has seized, in its bill. The fish, perchance, must be turned, and the mouthful of sea-water ejected. While the Pelican is arranging matters, the Gull alights on the great beak, leaning over to watch. No sooner is the bill opened than the sly Gull reaches in, seizes the fish, and flies away, we may well imagine laughing. The solemn old Pelican sits there blinking, too much astonished at first to move. Finally the dead truth seems to dawn on the dull mind. With a few disgusted flaps, away it goes in pursuit of another fish.*

Birds of America, Editor-in-chief, T. Gilbert Pearson, Garden City Publishing Co., Inc., Garden City, N.Y., 1942, Part II, p. 106.

Letter 12, page 17 — See: *FWSM*, pp. 40, 54 for information on Cedar Keys. Cedar Keys is situated on the Gulf Coast. In the 19th century it was the Gulf terminus for one of Florida's earlier railroads, which ran diagonally across the state from Fernandina. Troops were there due to Klu Klux Klan activity, according to Wyman's diary. Information on the Miami River is found in the following passage from Jeffries Wyman's diary for March 6, 1869:

> *Had a comfortable night & after breakfast made preparations to go into the bay. Channel narrow, wind ahead, short tacks – & when near light house pilot came aboard – who took us up to within a mile and a half of Miami River – Rowed to village – When we saw Mr. Hunt & a few others – This village consists of a few houses built during Indian war – one in poor condition – The general view of the settlement is however quite picturesque, shore lined with mangroves, behind these cocoa-nuts –*

Entries for the following days tell about going into the Everglades, and he describes the islands and the saw grass.

Letter 13, page 18 — Prof. Agassiz was the great Harvard zoologist and teacher. See: *Louis Agassiz, His Life and Correspondence*, edited by Elizabeth Cary Agassiz, Houghton Mifflin, Boston, 1885.

Letter 14, page 19 — Bethlehem refers to the town in New Hampshire. See: *FWSM*, p. iii.

Letter 16, page 21 — The Glen House is at the foot of Mt. Washington in the White Mountains of New Hampshire.

Letter 17, page 23 — See: *FWSM*, pp. 9, 10, 12, 33, 78 for additional information on Old Town. It was located on the west bank of the St. Johns River, directly west of the town of Deland. Goggin identified it as the settlement later called St. Francis, which had a post office from 1888 until 1909. Dr. Storer is David Humphreys Storer. See: Gifford, George E., Jr., M.D.,"Ichthyologist Dean," *Harvard Medical Alumni Bulletin*, vol. 39, no. 1, Fall, 1964, pp. 22—27.

Letter 18, page 24 — This letter was written from Germany, not Berlin, New Hampshire or Massachusetts. Asa Gray says:

> One winter was passed in Europe, partly in reference to the Archaeological Museum, partly in hope of better health; but no benefit was received.

Gray, A. & Others, *Jeffries Wyman*, Memorial Meeting of the Boston Society of Natural History, October 7, 1874, p. 18.

Letter 19, page 26 — Gorham is in the White Mountains of New Hampshire. Uncle Morrill is Morrill Wyman, M.D. (1812-1913). He graduated from Harvard with his brother Jeffries. In 1850 he performed the first thoracentesis. He was a physician at Harvard and practiced in Cambridge. See: Kelly, Howard, and Walter Burrage, *American Medical Biographies*, The Norman Remington Co., Baltimore, 1920, p. 1274. Goggin, John M., *Space and Time Perspective in Northern St. Johns Archeology, Florida,* Yale University Publications in Anthropology, No. 47, New Haven, 1952, p. 87, fn. 5.

Letter 21, page 29 — See: *FWSM*, pp. 3, 4, 49, 50. Horse Landing is on the west bank of the St. Johns River about ten miles south of Palatka. Mr. Peabody is George Augustus Peabody. See: *South American Journals 1858-1859 by George Augustus Peabody*, edited from the original manuscript by John Charles Phillips. Peabody Museum, Salem, 1937, pp. IX-XI. The illustration is one he sent to Jeffie of a wild hog.

Letter 24, page 34 — See: *FWSM*, pp. 12, 21, 23, 24, 25, 78, 82, 83. Blue Spring is eight miles southwest of Deland. Today, a small state park is located there.

Letter 25, page 35 — Hibernia was an early settlement on the west bank of the St. Johns River, about 25 miles south of Jacksonville. The big hole in the ground is doubtless what is called "The Devil's Millhopper." It is a large opening in the ground where the limestone strata underneath gave way many years ago. About 200 feet in diameter, its depth is perhaps 100 feet. It has recently been acquired by the state and is being built into a state park. It is in Alachua County, about 5 miles west of Gainesville.

Letter 30, page 42 — Savannah, Georgia. Mr. Forbes is Captain Forbes, *South American Journals 1858-1859 by George Augustus Peabody*. The pamphlet which Jeffries Wyman requests was probably the one which was published in 1868 in *American Naturalist*, vol. II, no. 8 and 9, "An Account of the Fresh-water Shell Heaps of the St. Johns River, East Florida," pp. 393-403, 449-463, Salem, Mass.

Letter 32, page 45 — See: *FWSM*, pp. 31, 32, 81. Hawkinsville is on the west bank of the St. Johns River, opposite the town of Deland. Later called Crow's Bluff, it is still so called today.

Letter 34, page 48 — See: *FWSM*, pp. 12, 32, 78, 81, 83. Osceola Mound is on the west bank of the St. Johns River, 5 miles west of Deland.

Letter 35, page 49 — Professor Josiah Parsons Cooke (1827-1894) was a chemist and

mineralogist. See Russell, Foster W., *Mount Auburn Biographies*, by the proprietors of the Cemetery of Mt. Auburn, Cambridge, Massachusetts, 1953, p. 42.

Letter 37, page 51 — The steamboat ran from Hibernia to Jacksonville.

Letter 38, page 52 — Princeton, Massachusetts is in the center of the state. Jeffie was staying on a farm.

Letter 39, page 53 — Biddeford Pool is on the coast of southern Maine.

Letter 40, page 54 — Gorham Hill is in New Hampshire.

Letter 41, page 55 — 1872 "Exploration in Florida," *Peabody Museum Annual Report*, Boston, pp. 22-25.

Letter 43, page 57 — See: *FWSM*, p. 23. Alexander's Spring is 5 miles south of the St. Johns River, a short distance south of Lake Dexter. For additional information on Orange Mound see: *FWSM*, p. 35. Goggin, p. 24.

Letter 44, page 59 — See: *FWSM*, pp. 24, 26, 27, 30, 47, 78. Goggin says Huntoon Creek is now known as Snake Creek. It is 10 miles southwest of Deland.

Letter 46, page 61 — In reference to cannibalism, see: *FWSM*, pp. 60-72. "Human Remains in the Shell Heaps of the St. Johns River, East Florida, Cannibalism," *American Naturalist*, vol. 7, pp. 403—414, Salem, Mass., 1874. Peabody Museum, Annual Report, vol. 7, pp. 26—37, Boston.

Letter 51, page 67 — "On the Wekiva," see: *FWSM*, pp. 12, 22, 78. The Wekiva flows out of a swamp to join the St. Johns River 5 miles northwest of Sanford.

Letter 57, page 73 — Dr. Hagen is Herman August Hagen (1817-1893). He was an entomologist and professor at Harvard from Königsberg, Prussia. Agassiz, Elizabeth C., *Louis Agassiz, His Life and Correspondence*, Houghton Mifflin and Company, Boston. Bouvé, Thomas T., *Historical Sketch of the Boston Society of Natural History*, Boston, published by the Society, 1880, p. 188.

Letter 59, page 75 — Dr. Baird is Stephen Fullerton Baird. "Stephen Fullerton Baird" by A. Healy Dall, *Dictionary of American Biography*, J. B. Lippincott, Philadelphia, 1915, p. 169.